IMAGES OF AMERICA

MEMPHIS

IMAGES OF AMERICA

MEMPHIS

JOHN DOUGAN

ARCADIA
PUBLISHING

This book is dedicated to my grandparents, Robert Earl and Sarah Velma Smith, and Sidney Sutton and Margaret Dougan. The stories they told of their early lives inspired me to love and value history.

Published by Arcadia Publishing
Charleston SC, Chicago IL, Portsmouth NH, San Francisco CA

Printed in the United States of America

Library of Congress Catalog Card Number: 2003107143

For all general information contact Arcadia Publishing at:
Telephone 843-853-2070
Fax 843-853-0044
E-mail sales@arcadiapublishing.com
For customer service and orders:
Toll-Free 1-888-313-2665

Visit us on the Internet at www.arcadiapublishing.com

Contents

Introduction

This photographic history shows a frame-by-frame view of many major themes of Memphis history from its redevelopment after the 1870s yellow fever epidemics to the end of World War II. Because of this time limitation, many of those elements most associated with Memphis—Elvis Presley, FedEx, and hundreds of other modern developments—are not included. However, this volume does look at the culture from which the Blues and Rock 'n Roll evolved, as well as the city's innovations in transportation and delivery.

The book begins with a look at Memphis' regional roots. The "City on the Bluff" owes much of its growth to the thriving hardwood timber and cotton farming industries in the rich Mississippi River bottomlands that surround the city. As these areas were cleared and changes in cotton farming eliminated the need for large numbers of agricultural workers, many rural residents found homes and jobs in Memphis. The great floods of the 20th century brought thousands of dislocated residents to Memphis for the first time. The hardships and trials of rural life created fertile ground for the rich music that Beale Street produced.

The city's Mid-South location on the Mississippi River provided tremendous opportunities for growth as a transportation hub. The majestic steamboats that plied the western waters gradually found themselves being replaced by railroads, highways, and air travel. The Frisco and Harahan Bridges, spanning the mighty Mississippi, provided quick and easy railroad and highway access to the West. With the rapid development of the automobile, the Memphis riverfront, once a vast storage area for thousands of cotton bales, became a parking lot for the expanding business community.

The city grew up and out as skyscrapers increasingly dominated the downtown skyline. Workers commuted by trolley or automobile from the suburbs. In addition to business and industrial expansion, small neighborhood stores opened to meet the needs of a growing city. Nevertheless, residents of the city and its surrounding countryside continued to shop and seek entertainment on Main Street, Beale Street, and at the Mid-South Fair. Although an urban center, Memphis has retained much of its small-town heart.

All of the photographs in this book came from the Memphis/Shelby County Public Library and Information Center History Department collections, which include the Memphis and Shelby County Room photograph and manuscript collections and the Memphis/Shelby County Archives. A large number of the photographs were taken by two contemporary commercial photographers, J.C. Coovert and Clifford H. Poland. Coovert began his photographic career in Memphis at the turn of the century and continued to work until his death in 1937. Poland's photographic career in Memphis spanned from 1912 until his death in 1939. Other photographs were selected from the History Department's wide-ranging collections, many of which have grown in size and quality because of donations by hundreds of people.

Profits from the sale of this book will go to the Memphis and Shelby County Room of the Memphis/Shelby County Public Library & Information Center.

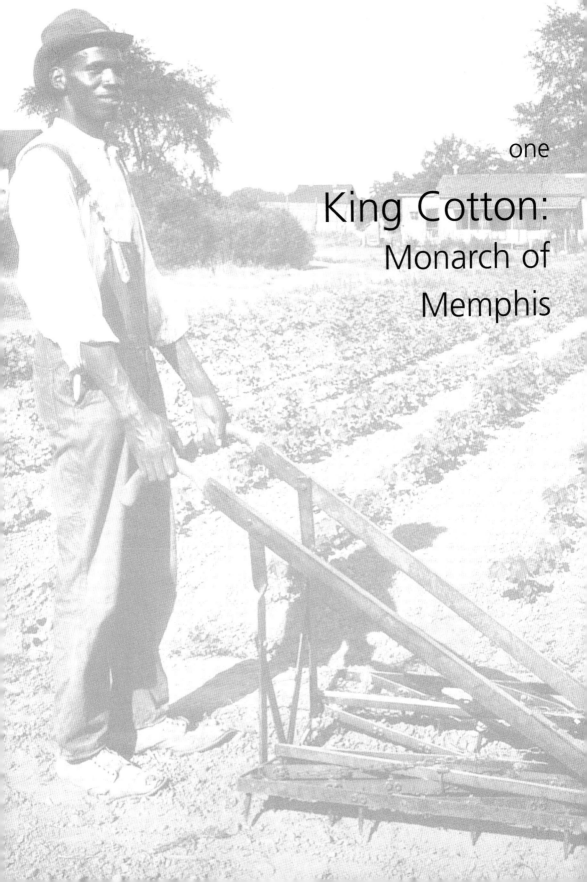

one

King Cotton:
Monarch of
Memphis

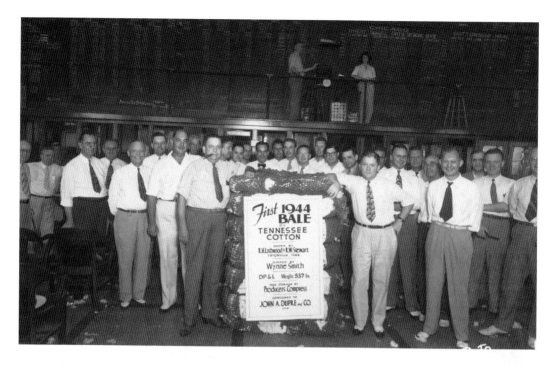

In 1826, a group of Fayette County farmers brought 300 bales of cotton to Memphis by ox-cart. This began what would become the heart of Memphis industry. By 1941, Memphis was the "World's Largest Cotton Market." Much of the growth of the Memphis cotton industry can be attributed to its central location in the South's "Cotton Belt" and to the Memphis Cotton Exchange, which was founded in 1873. Pictured in this view, activity on the trading floor of the Exchange comes to a halt for a photo opportunity with 1944's first bale of Tennessee-grown cotton. Today, technology replaces the need for ticker tapes, quote boards, and possibly even the spittoons next to each chair. This photo also documents a recent change at the Exchange. Until 1942, when Pauline Hightower was hired, all of the Exchange's board markers were men.

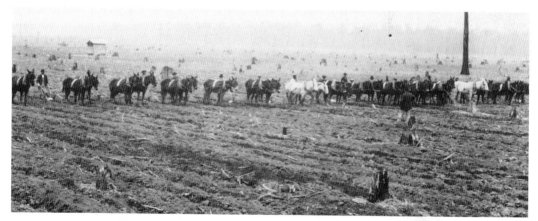

Before cotton could be planted on cleared land, the "new ground" had to be broken with turning plows, which dug into and turned up great furrows of earth. This photo shows 15 teams of mules plowing a field covered with stumps and even a lightning-struck snag. Each time the plow struck a root, the plowman would receive a bone-rattling jar.

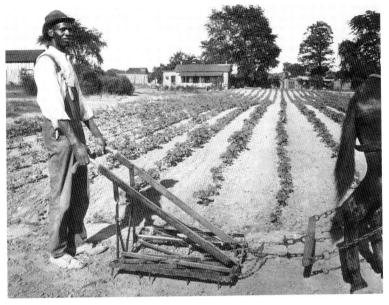

After the cotton had been planted and the plants were several inches tall, the cotton was "chopped" to give the plants room to grow and prevent grass and weeds from growing in the rows. Here, a farmer is harrowing the middles to keep weeds and grass from growing between the rows. His appearance shows the physically demanding nature of long, hot hours behind a plow and mule.

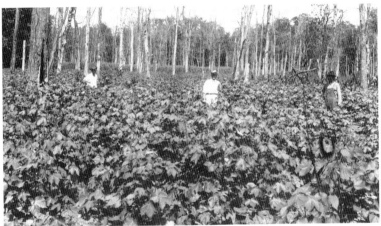

Farmers often only partially cleared bottomlands before planting their crops. Here, three farmers are admiring their cotton, which is planted at the edge of a swamp. The trees in the plowed area are dying either from root damage caused by plowing, or from fires set to burn off the underbrush so the area could be plowed.

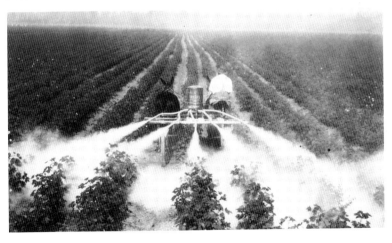

Early in this century, the arrival of the boll weevil in the Mid-South created the need to dust cotton with insecticides. Although contact with cotton poison was extremely harmful, its use was necessary to prevent the cotton crop from being completely destroyed. The mule on the right is doing twice the work, pulling his share of the load while carrying the farmer.

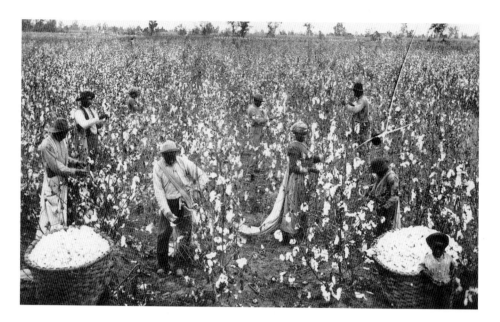

Once the cotton plant bloomed and the fibers of the boll developed, the stalks died and the cotton was ready to pick. Even the youngest children were brought to the field to pick whatever they could. J.C. Coovert captured this image "in tall cotton." These stalks appear to be over 5 feet tall, and each has more than 30 bolls to a stalk. The white oak baskets are also a unique feature of this photograph.

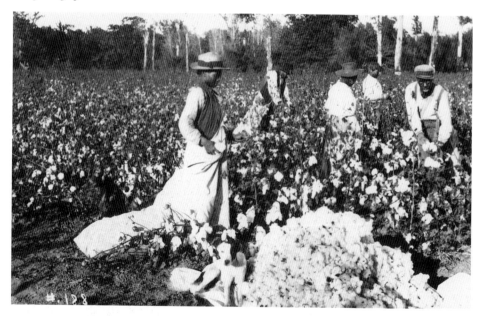

When picking cotton, the end of the row was always a welcome spot, as it may have offered the only place in the field with any shade. It was also where workers emptied their picking sack and got a drink from the water bucket. Pictured here, a dog is guarding someone's pile of picked cotton. Note the trash mixed in with the cotton. Only the most precise pickers could pull the cotton from the stalks without pulling leaves and bolls.

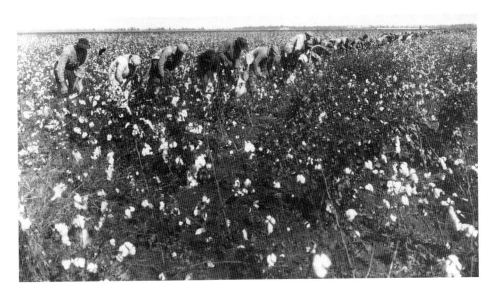

In the large cotton fields of Arkansas, hundreds of pickers were needed for the harvest. After the Harahan Bridge was built, thousands of Memphis workers were recruited every day during cotton-picking season. They were loaded on buses and trucks at 4 a.m. and transported across the river to the fields. Although apparently posed, this photo shows workers stooping to pick cotton from shorter stalks.

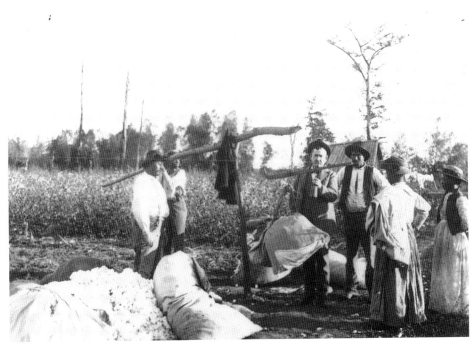

At the end of the day, every worker's cotton was weighed separately so each could be paid for the amount picked. Three hundred pounds was a good day's work, but only a few pickers could gather that much cleanly. Various sizes of weighted "peas" were adjusted along the calibrated scale to determine the weight, much like scales in a doctor's office today.

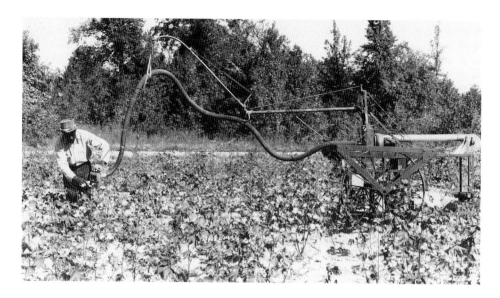

The history of mechanical cotton pickers is closely linked to Memphis. This connection began when Samuel Rembert and Jedediah Prescott invented the first mechanical cotton picker in 1850. Their invention was never mass-produced for fear that it might displace the need for slaves to pick cotton. By the turn of the century, various forms of suction-type cotton pickers, such as the one pictured above, were in use. The man shown must be demonstrating how the machine works because the cotton doesn't seem to be accumulating anywhere.

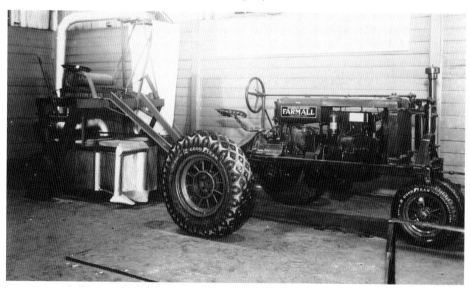

Memphis is better known for the cotton pickers manufactured by the companies represented in this picture. The Rust Cotton Picker (left), which was perfected by John and Mack Rust in the mid-1930s, revolutionized the cotton industry by cutting picking costs to one-tenth the cost of hand-picking. The Rust manufacturing plant was located on Florida Street. McCormick-Deering, which became International Harvester, eliminated the need for a tractor to pull the cotton picker by creating the self-propelled-style pickers that are still used today. From the first year of production in 1948, these machines were built at the Memphis International Harvester plant.

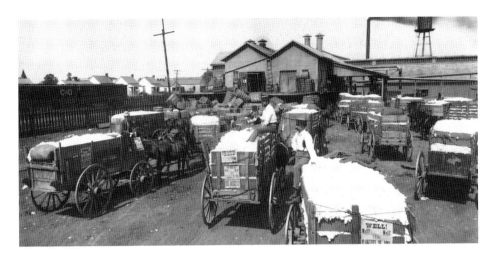

As the cotton industry developed after the Civil War, by-products like cottonseed oil, cottonseed meal, and linters were often as valuable as the cotton fibers themselves. They were used to make everything from Ivory soap to Crisco. This might explain the wagon tailgate advertisement: WELL! WELL! WELL! THE PLANTERS OIL MILL WILL GIN YOUR COTTON FOR NOTHING! JUST FOR FUN! The mill could afford to gin the cotton for free by selling the former waste products for a profit. The details of the photograph also show another catch to this free service. The wagon drivers apparently came prepared for a long wait. One driver holds an umbrella while another has a book in his hand.

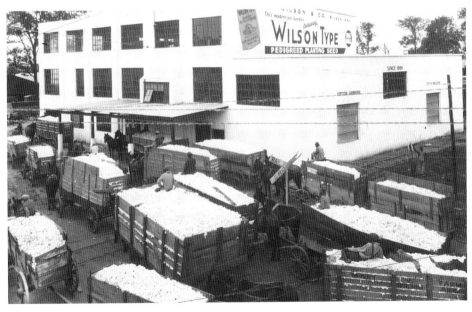

The wagons tell most of the story in this image of the Wilson, Arkansas gin. Most of the wagons are much larger than those in the previous shot because they were designed specifically to haul as much cotton as possible. The wagon driver was forced to drive his team while perched on the load of cotton. Even the smaller wagons are hooked in tandem so that one pair of mules can pull twice the load. Cotton that appears to "leak" between the boards has been "tromped" into the wagons in an attempt to pack as much as possible in each load.

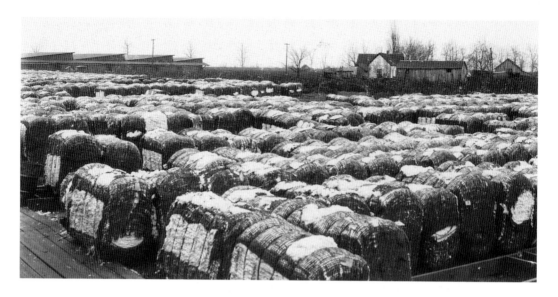

During the ginning season, cotton was baled faster than it could be shipped to Memphis. The ginners' warehouses quickly exceeded their capacities, and the bales were often stored outside. They were placed on frames that kept the bales clean and dry by elevating them off the ground. The breaks in the burlap coverings show where the cotton samples were taken.

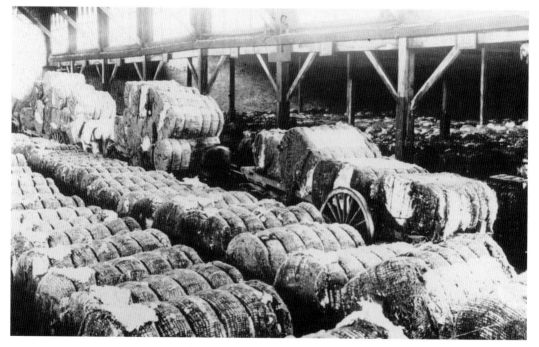

This interior of a Memphis cotton warehouse shows the cotton drays that were used to move the bales around the city. At the gin, the burlap-wrapped, metal-banded bales were marked with codes or tags. These codes were used to track the ownership of each bale as it was transferred from the farmer (who grew the cotton) to the ginner (who frequently bought what he ginned) to the cotton factor (who sold it on the Exchange) to the manufacturer (who used it to make cloth or other products).

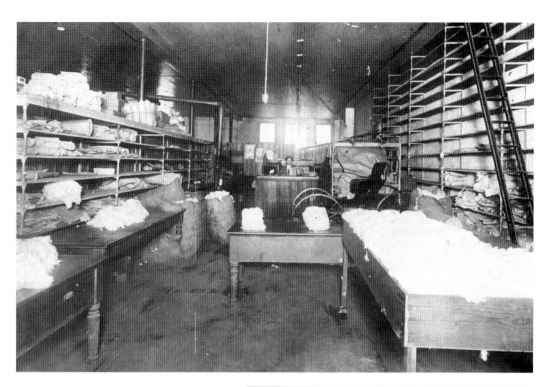

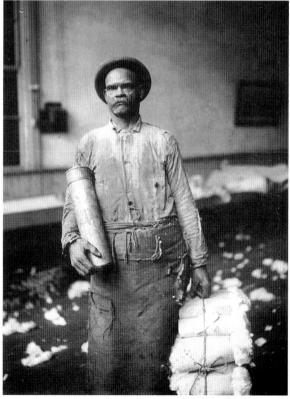

Above: Samples from each bale of cotton were taken to the offices of cotton factors on Front Street, where they were "classed" by grade, color, and staple, and then stored on shelves all the way to the ceiling. The loose cotton was eventually bagged as "snakes" and frequently sold to benefit local charities. Parking space may have been limited downtown when this picture was taken, since the owner has his buggy disassembled and parked next to his desk.

Right: This photograph shows a worker in a cotton factor house carrying a core sampling tool and a bundle of cotton samples ready to be classed. This is an artistic example of the work of amateur photographer Henry Frank. The image is believed to have been taken in Godfrey Frank's cotton office.

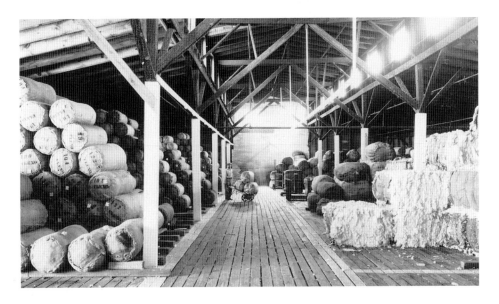

The "Cotton Pickery" of McCallum and Robinson was located at the corner of Mallory and South Lauderdale Streets in the late 1910s. This area of the warehouse shows typical storage for both "snakes" (on the left) and their contents, once they have been rebaled (on the right). A modern cotton scale is also shown on the right side of the aisle.

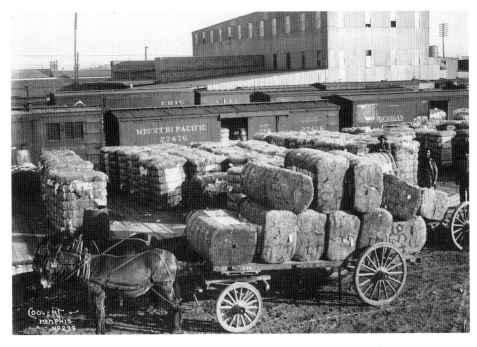

Once cotton was sold on the Exchange, it was ready to be shipped to its manufacturing destination. Early in Memphis history, this was done predominately by steamboats (see p. 57). However, with the post–Civil War growth of railroads, boxcars became the quickest and most efficient means of transporting cotton bales to buyers across the United States or to port cities where they could be shipped overseas.

two

Memphis:
Hardwood Capital
of the World

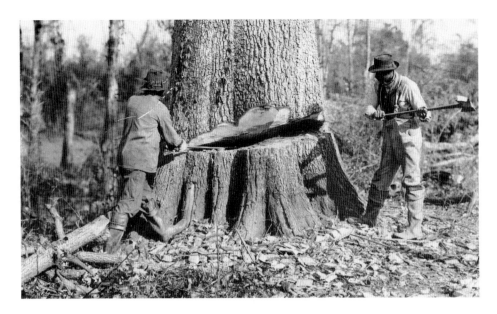

The frequent cry of "timber!" at the turn of the century heralded Memphis' second-most important industry. The massive tracts of virgin hardwood timber in the bottomlands surrounding Memphis attracted the attention of many local and national companies. Hardwood timber was used to make everything from barrel staves and crossties to furniture and early car frames. At one time, Memphis had over 30 major sawmills, in addition to numerous hardwood manufacturing companies. Felling the massive trees required skill and precision. After sawing halfway through a tree with a cross-cut saw, the lumbermen chopped a wedge out of the back side of the tree to guide the direction of its fall. The double-bit axes were extremely sharp, as the large wood chips at the base of the tree show. The swampy condition of the bottomland is implied by the thigh-wader boots the men are wearing, though in this dryer spot, they have them rolled down below their knees.

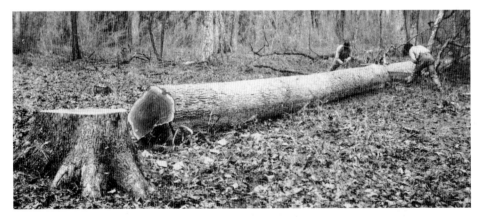

After a tree was felled, it was topped and cut into manageable lengths. In this view, the top of the tree is being cut off just below the first limb. Although this wasted a great deal more of the tree than would be the practice today, the boards of this period were almost totally free of knots. If you look closely, you can see that wedges have been driven into the saw kerf above where the men are sawing. This kept the weight of the tree from pinching the saw when the log was almost cut in two.

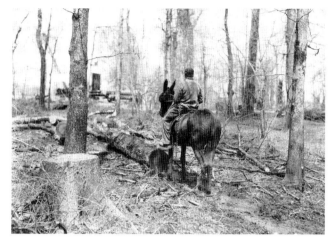

This image shows a mule being used to snake individual logs out to an area where they could be loaded onto log wagons. The "skidder" attached one end of the chain to the log while the other end of the chain was attached to the mule's harness. The log was then snaked to its destination by the mule and its rider.

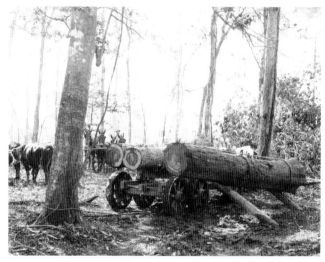

Log-chains were used to roll logs onto the wagons. This lost art required knowledge of practical physics and a little bit of luck. If a chain slipped, the log would either roll back off or roll too far and turn the wagon over. In this picture, two chains are being used at different angles in an attempt to control the loading of the logs. A broken cable wrapped around the tree bears evidence of an unsuccessful loading attempt.

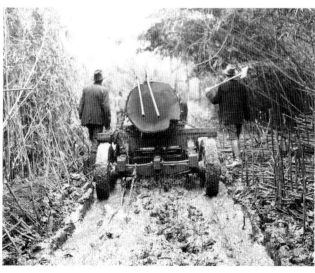

Where was the photographer when he took this picture? He may have been knee deep in the mud. At times it may have been easier to load only one log on the wagon, particularly if there was a danger of getting stuck. Here, the wagon road is cutting through a canebrake. The man on the right is carrying his ax in a casual fashion. Hopefully, he did not trip on one of the cane stobs.

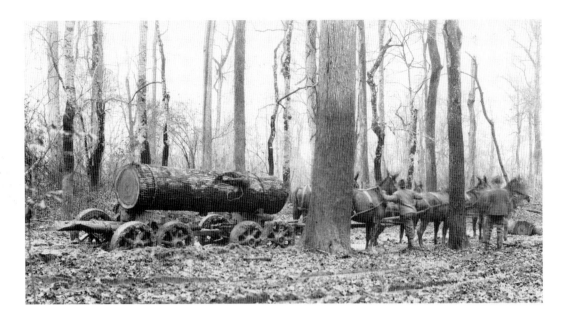

The routes of the wagons were often varied to avoid bogging down in the ruts of previous trips. This wagon is mired in the mud. The reason the right-hand side of the picture appears to be blurred is that the men and mules are moving; the wagon and log are not.

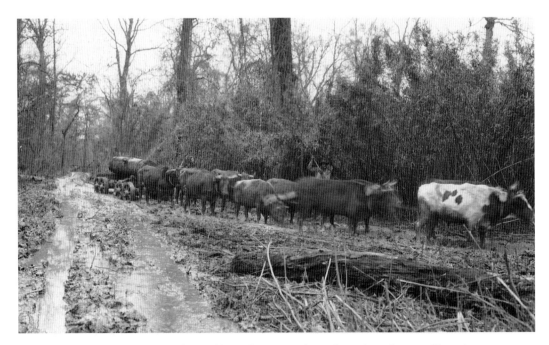

Oxen were also used to pull wagonloads of logs. This picture shows five yokes of oxen pulling a large log through deep mud. The fork in the log road, which had been an impassable canebrake, is now a quagmire of muck and broken fishing cane. The driver is using one of the canes to encourage the oxen to pull the heavy load.

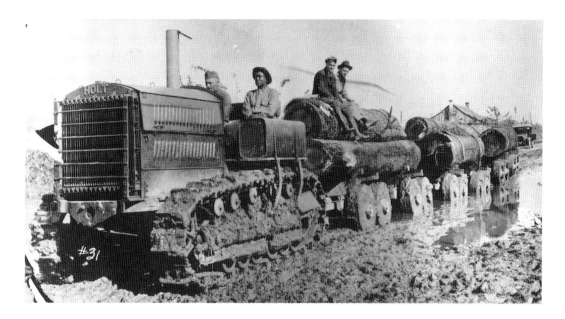

Not to be outdone by teams of mules or yokes of oxen, bulldozers were also used in more accessible areas. In this photo, the bulldozer operator appears to be dressed in a military or Civilian Conservation Corps uniform. A closer inspection suggests that the two men riding on the first log wagon, one dressed in a trenchcoat and the other with his coat draped over the top log, may have abandoned their car and are catching a ride across the impassable mud hole. If so, they left their car door open.

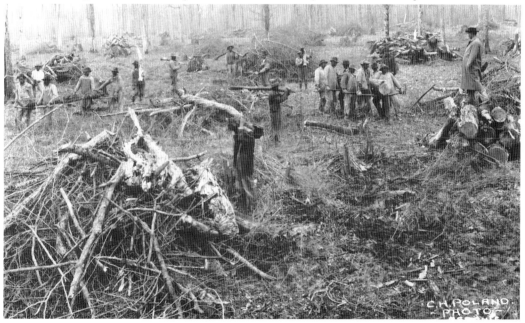

Once an area had been logged, the logs and brush were often stacked and burned. Free of obstructions, the fertile bottomlands could then be plowed for crops. In this photo, some men carry smaller logs on their shoulders while larger logs are carried by groups using poles to support them. A supervisor stands atop a pile of logs to get a better view of the work.

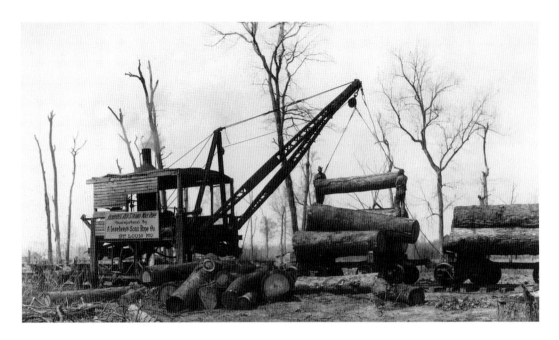

The wagons usually brought the logs to the end of a temporary railroad line, which was built by the lumber company. There, steam-powered cranes loaded the logs onto flatbed rail cars for transport to Memphis. The cable-equipped crane slowly lowered the logs into place. Each car could carry up to six logs, depending on their size and how well they stacked with the other logs.

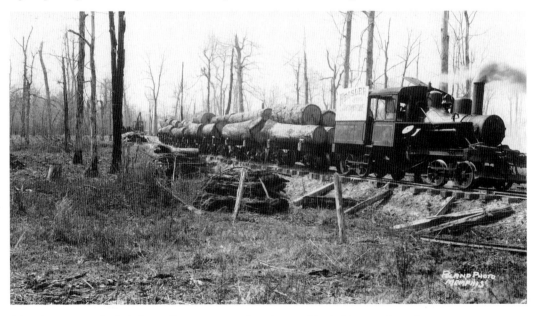

After the cars were loaded, the small steam-powered engine would wind its way along the temporary line until it reached a main line. There it would switch over and bring the load of logs to its Memphis destination. The crane can be seen in the distance. It is interesting to note that the logs were not chained down to keep them on the rail cars. As heavy as they were, they probably would not shift as they slowly moved along the sometimes quickly constructed temporary tracks.

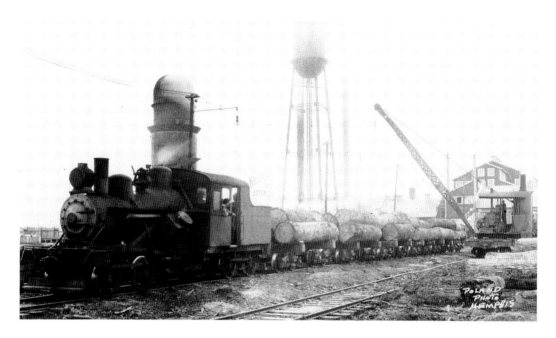

Once the log train arrived at the mill, the cars were backed in and unloaded by another crane. The crane in the log yard was mounted on a separate set of tracks so that it could unload an entire shipment without having to move the train. The mill and water tower can be seen in the background.

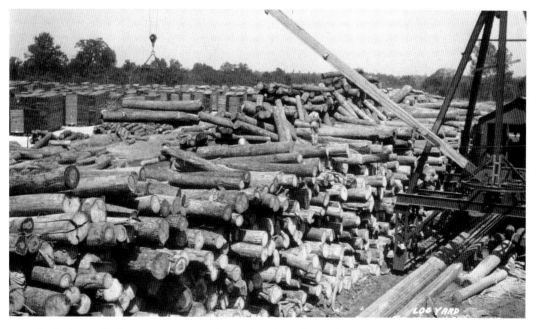

In the log yard, a larger crane was used to stack and sort logs and put them on the conveyor, which carried them into the sawmill. The man on top of the logs had the difficult job of climbing across the mountain of logs and attaching or freeing the hooks. Note the orderliness of the first row of logs and the disarray of the second tier. It may have been a discard pile or a stacking project to fill time while the operator waited to send another log to the mill.

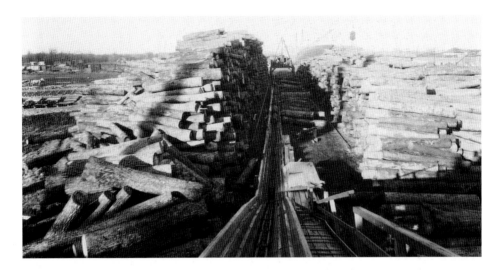

Lumber sawed at the Fisher Body Company plant in Memphis was used to build frames for early General Motors automobiles. In this view, the conveyor moves several logs up a steep grade to the mill. Notice the treads nailed to boards at the right of the conveyor, which form a stairway up into the mill.

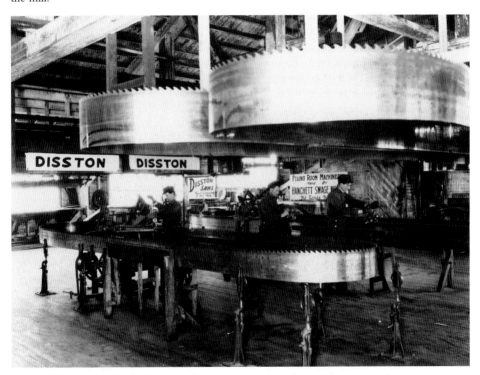

One of the most important jobs in a sawmill was that of the saw sharpeners and setters. The specialized tools used by the men in this photograph were designed to ensure that each sawtooth was set and sharpened precisely the same as the others. The two large blades at the top of the picture are actually optical illusions. Apparently, they were stored closer to the shutter of the camera, which makes them appear larger.

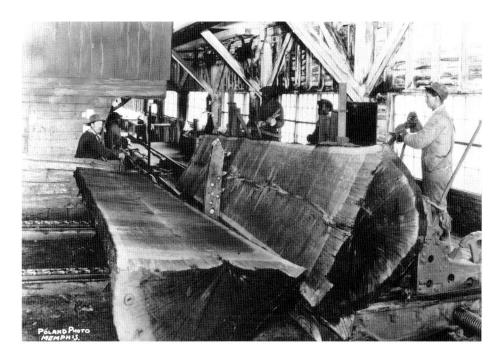

The saw mechanism of the mill required five men for its operation. Three men operated the saw, one oiled the machinery, and one tailed the boards as they were cut from the log. After coming down the conveyor (left), this log has been cut in half and then brought back the first board can be cut off the right half of the log while the left half waits its turn. Note that the bark on the tree seems to be several inches thick.

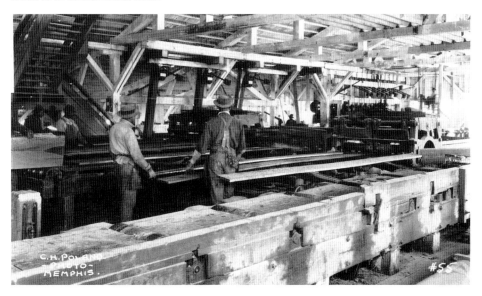

Once boards were rough-sawed, they were cut to a more uniform width and thickness in the planer division of a sawmill. This photo shows boards being planed as soon as they were cut to ensure that they dried evenly. On the left is a steam radiator that was used to keep workers warm in the winter.

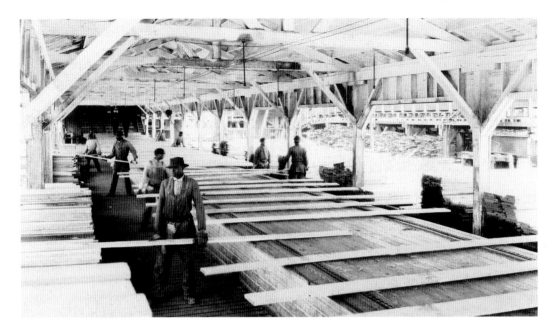

Once the sized boards left the mill, they were sorted by width and grade, with bark cuts and bowed boards stacked separately. At the far end of the photograph, two men in suits are walking on the middle of the conveyor. The workers are wearing heavy gloves to protect them from splinters.

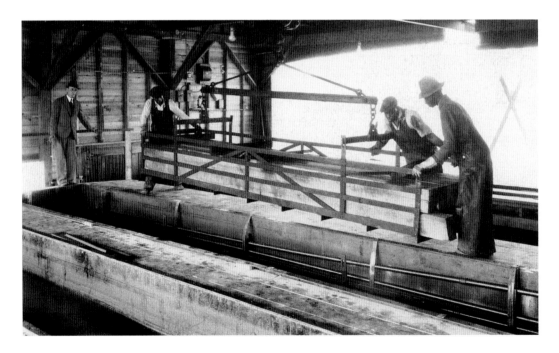

In this view, crossties are being lowered into a creosote vat at the E.L. Bruce Company. A world leader in the hardwood industry, E.L. Bruce was also a leader in wood preservation and treatment. It is the parent company of the now internationally known company, Terminix.

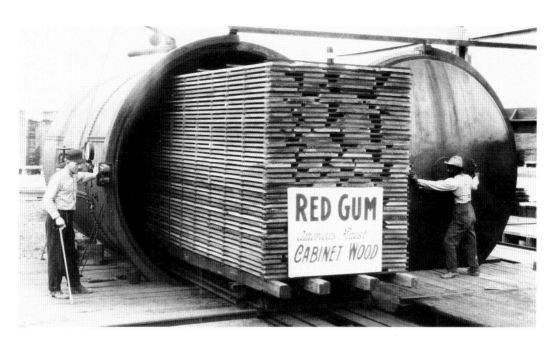

Pressure treatment was another method used to preserve wood. Here a large skid of red gum boards is being rolled into a pressure chamber at the Fisher-Hurd Lumber Company. The worker on the right is waiting to slide the door into place. Notice the use of spacers to ensure circulation around each of the boards.

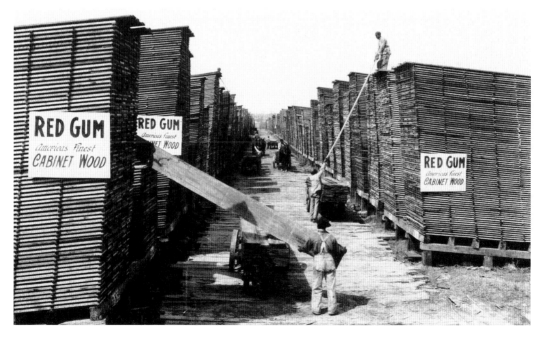

After being treated, boards were stacked outdoors to dry. This practice kept the boards from bowing or warping. A close examination of these boards shows them to be about 2 feet wide and 18 feet long. Considering the height of the stacks, their uniformity is amazing. The boards could have been stacked even higher had they been longer so the man on top could reach them.

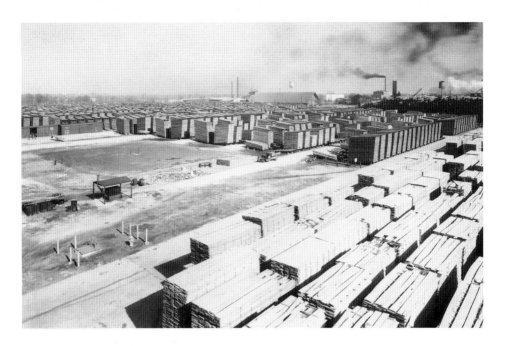

The lumber yards of some sawmills could have several million board-feet of lumber in their stock at any time. The Fisher Body Company lumber yard did have two novelties that their rival yards may not have contained. One is what appears to be an all-wooden truck, though we can only assume the motor had some metal in it. The other more unusual item is the pair of tennis courts. Match point must have been extremely grueling after a day of stacking lumber.

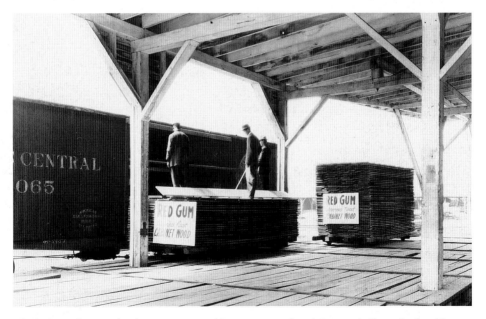

The last stop for most lumber cut in Memphis was, more often than not, similar to its first. The dried, finished lumber was loaded into boxcars to be shipped anywhere in the United States to customers who wanted "America's Finest" hardwood.

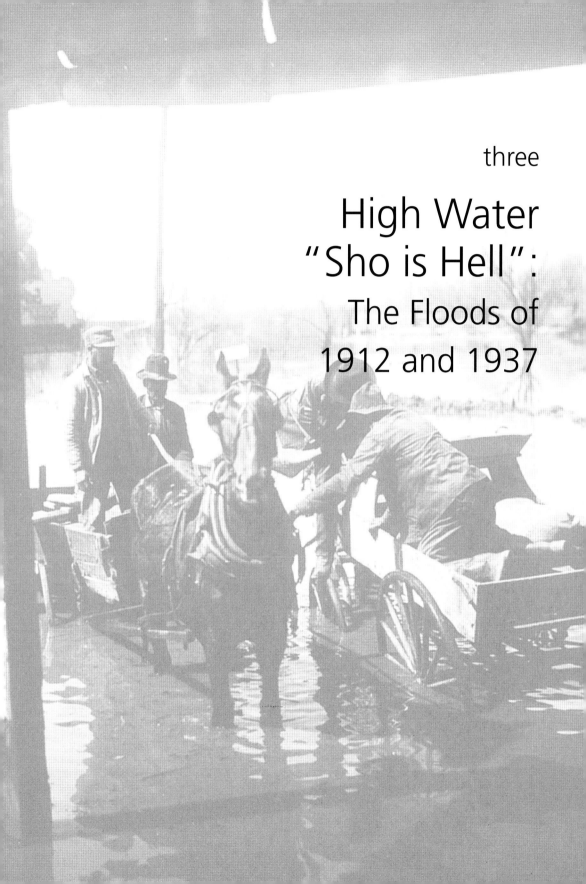

three

High Water
"Sho is Hell":
The Floods of
1912 and 1937

three

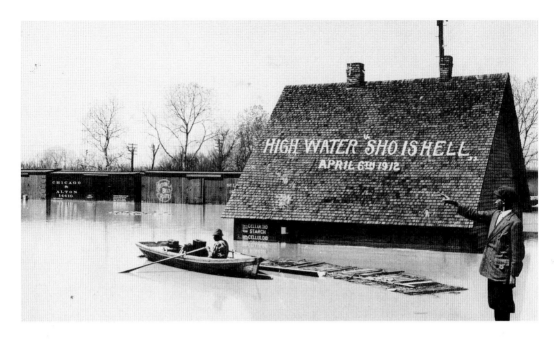

Although Memphis is located high on the Fourth Chickasaw Bluff, it has not been unaffected by the great floods of the 20th century. The entire population of the Mississippi Valley suffered from the effects of the 1912, 1913, 1927, and 1937 floods. In 1912 and 1913, flood waters backed up the Wolf River, inundating Memphis' low-lying Pinch District. Thousands of area residents from the surrounding rural area were forced either to live on top of levies or to evacuate to Memphis. In 1937, Memphis served as a major refugee center for the thousands of Mid-Southerners who fled the devastating flood waters. The photographer's dramatic comment expressed the sentiments of many flood victims.

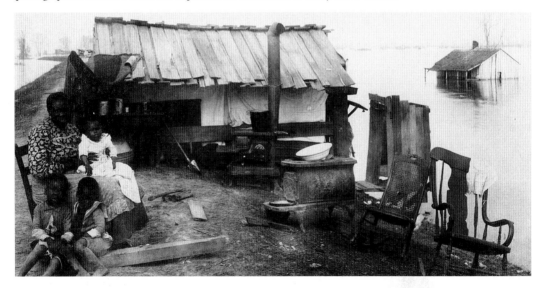

The only high ground for many of the victims of the 1912 flood was the levees built to keep the flood waters from escaping the river. This young mother and her children pose for a picture in front of their temporary home. She has managed to salvage her rocking chairs, stoves, dishpans, and lard buckets. Even the outhouse seems to have been moved to higher ground.

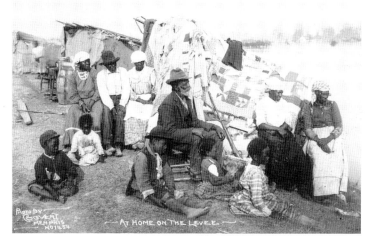

The lack of young men in many of the flood photos suggests they were away sandbagging levees and homes. Among the items saved by this group of refugees are an old muzzleloading rifle and an ax. Note the clothing and patchwork quilts, which show the colorful diversity of fabrics of that time.

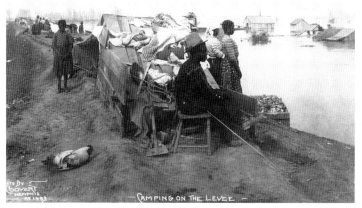

The chicken steals the show in this photograph. Everyone except the girl in the polka-dot dress seems to be watching the flood waters rise or fall. Without a way to saw boards for the front and back of the lean-to, the builder just nailed them on and let the boards stick out.

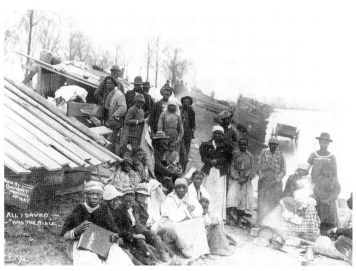

The caption says it all. Many rural residents had to leave what they could not carry and pray that the flood waters would not sweep away what they left. The woman holding the large Bible has saved her most prized possession. Family Bibles, such as the one shown, often contained pages for recording family births, deaths, and marriages.

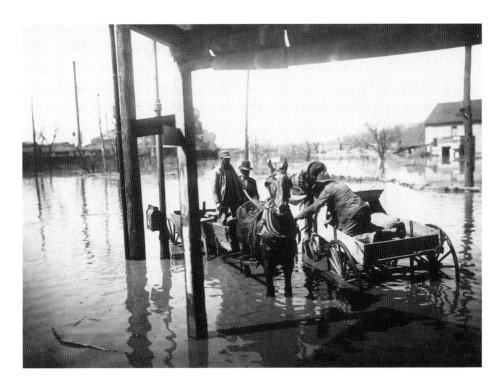

In 1912, high water from the Mississippi River backed up the Wolf River, flooding a 25-block area of the Pinch District, in what was then the northern part of the city. The drivers of the stranded wagons are working together to make it to higher ground.

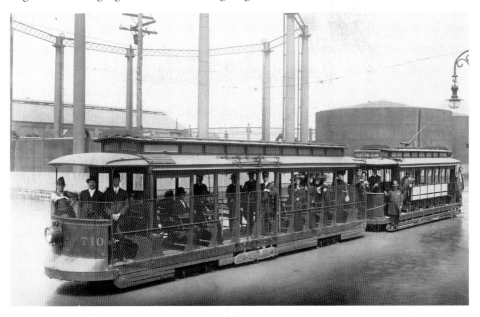

Flood water in the Pinch area made transportation difficult; nevertheless, trolleys continued to run. The water, which is over the trolley wheels, is so smooth that at first glance it is hard to distinguish it from pavement. Part of the Memphis Gas Works can be seen in the background.

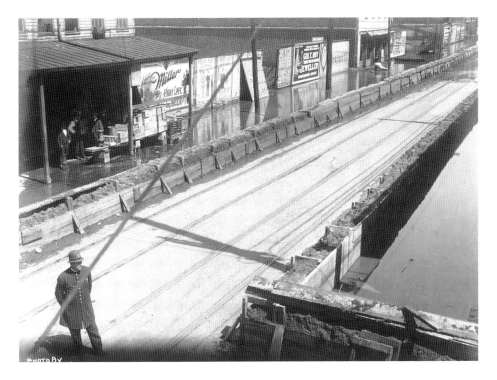

In this photograph, the police officer with his baton behind his back catches your attention. Billboards advertise Miller High Life Beer, Oak Hall clothing, Brod the Tailor, Haverty's Furniture, George T. Roy Jeweler, and Pantaze's drug store. Ironically, the earth-filled flood walls, built by the Memphis Street Railway Company to keep some of their lines high and dry, forced flood waters to rise in the surrounding businesses.

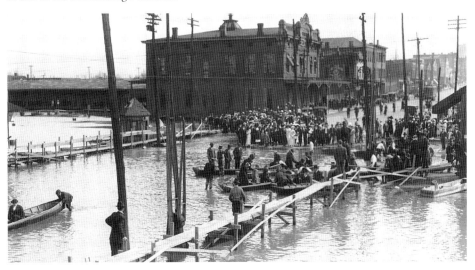

A crowd is gathered on North Main Street waiting for boat tours of the flooded area. No one seems to be using the elevated board sidewalks, but every boat inside the makeshift walkways is in use. The dress of the crowd hints that they were there to see and be seen. Note the tollgates and the hexagonal tollhouse.

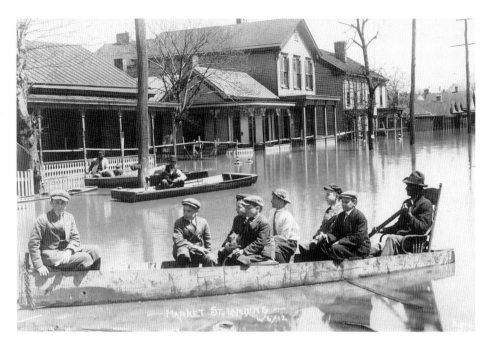

This group of young boys is being paddled to the cobblestones at the edge of the flooded area on Market Street. The homemade "box without a top" construction of the boat makes one hope the water isn't very deep. The paddler's rocking chair is a nice feature. Also note that the two boys seated on the left side of the boat are eating bananas. Since one of the other boys is holding a sack lunch, perhaps they were eating their lunch on the way to school.

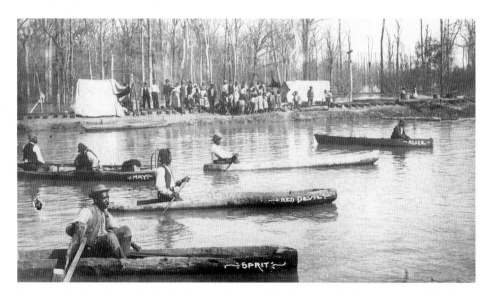

Photographer J.C. Coovert took the liberty of naming the boats, making it appear as though they were in a race. The dugouts and canoes seen here are of much better quality than the plank boats used by the city folk. The refugees in the background are using a raised railroad abutment as a campground until the waters recede. The cleared strips next to the railroad apparently provided an excellent canal for boat travel.

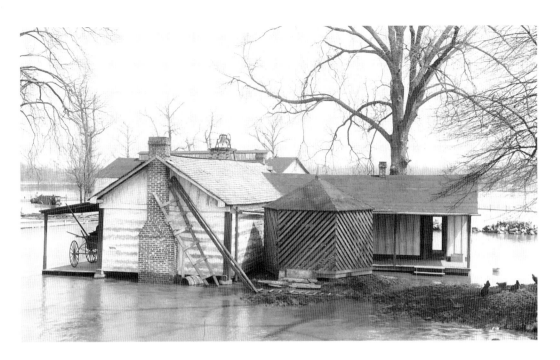

The low-lying areas of Arkansas were particularly hard-hit by the flood. This picture shows in great detail an Arkansas farm house and its surroundings, including chickens, firewood, a bell, floating barrel, and ladders. Of interest are the gazebo, log cabin, "dog-trot," stranded wagon, buggy on the front porch, and ventilation-louvered barn. Details are what really make photographs interesting.

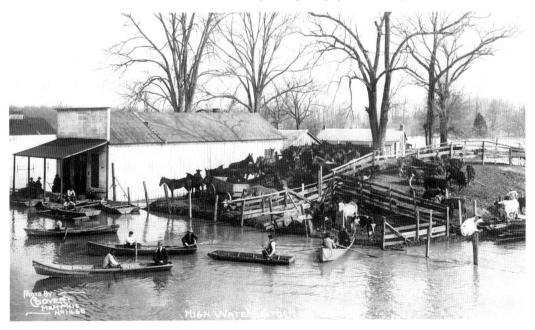

This is the same farm pictured in the previous photo. It was apparently large enough to have its own store. The knoll provided a high and dry place for livestock, though hay and feed were often difficult to come by during times of high water. It also appears that the knoll is partitioned to separate the animals.

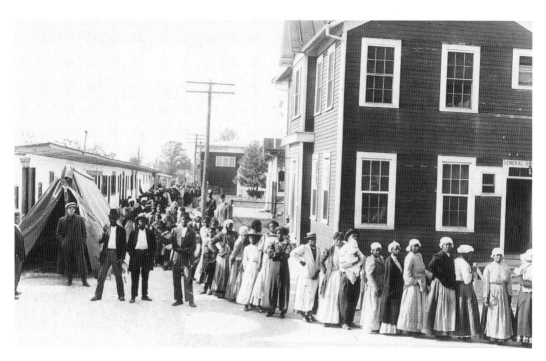

During the flood of 1912, each steamboat that arrived in Memphis brought hundreds of refugees to the city. Camp Ed Crump, named for the mayor of Memphis, was set up at the Memphis Fairgrounds. In this view, a group of women wait patiently in line, while two men lighten the mood by "hamming" for the camera. One man is displaying a hand-carved wooden six-shooter; the other is strumming his walking stick as if he were a left-handed banjo player.

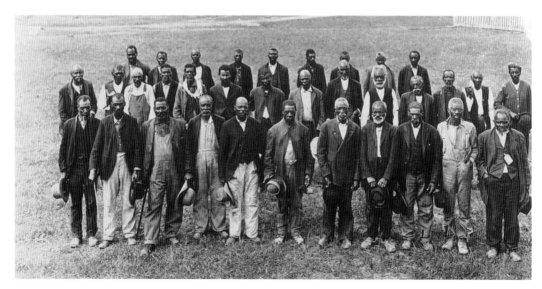

This picture was taken shortly after the Memphis Fairgrounds had been purchased, so much of the site was still undeveloped. The Fairgrounds were perfect for housing flood victims because the wide-open spaces allowed room to set up tents for refugees. Note the dignity and poise of these older men standing at attention with their hats off.

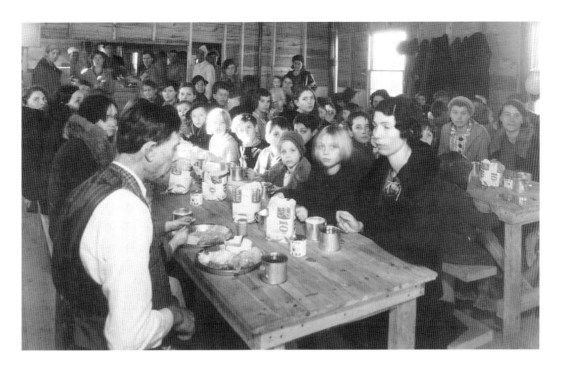

The 1937 flood affected many more people than the flood of 1912. More than 20,000 evacuees sought shelter in Memphis. The Mid-South Fairgrounds were again used as the primary refugee camp, but could only accommodate 5,000 people. The remainder overflowed into schools, hotels, and private homes. In this view, refugees are seen enjoying chicken, potatoes, beans, Pet milk, and 10¢ loaves of Colonial bread.

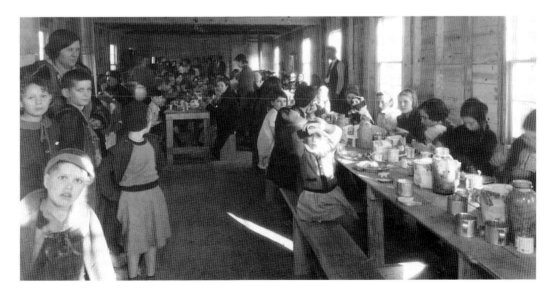

This group of refugees eats canned peaches from half-gallon jars while welcome sunlight streams through the windows. Thanks to better organization, those given relief in the 1937 flood often left better clothed than when they arrived.

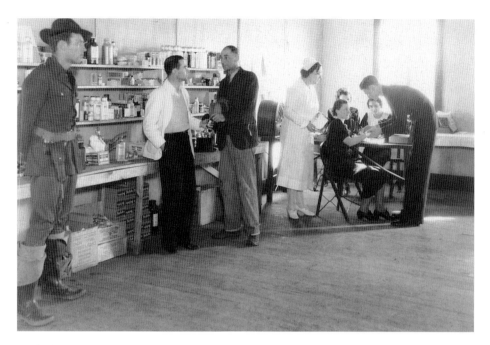

Medical attention was provided to the refugees because of the high incidence of contagious disease. In this posed picture, the pharmacist is giving a man some medication, while a very attentive lady is having her wrist bandaged by a medical assistant. The radio in the office kept everyone entertained.

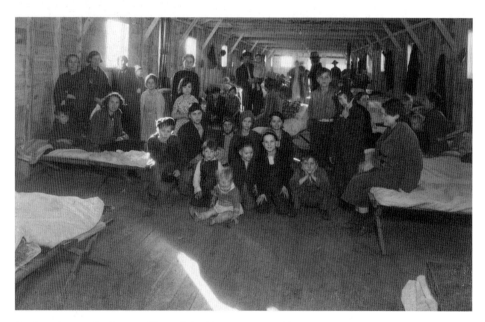

At the Fairgrounds, dozens of barrack buildings were quickly constructed to house the refugees. Because of health concerns, refugees were issued new blankets, quilts, and bedding. Note the straw coming out of one of the mattresses (left foreground). Two of the boys in this group, including the one making a face for the camera, are wearing aviators caps.

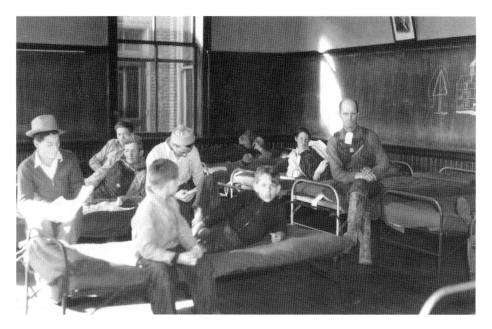

Memphis schools were also used to house refugees. To combat the monotony, two men are reading, and some of the children have used the blackboard for their artwork. The drawing of a house comes complete with a stove, stovepipe, and smoke curling out the chimney.

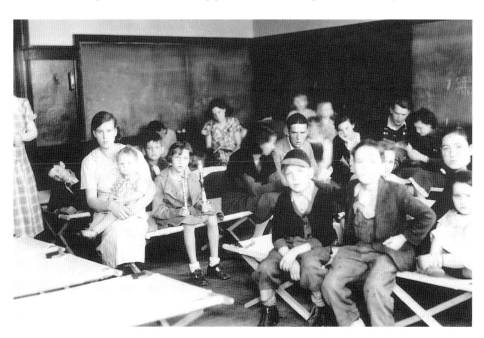

Name tags around individuals' necks are very noticeable in several of the refugee photographs. Upon arrival, each family was numbered and tagged in order to keep track of various family members who were separated. One small girl seems to be holding a two-piece musical instrument. The blackboard graffiti in this image is a little less detailed; all that is visible is a game of tic-tac-toe.

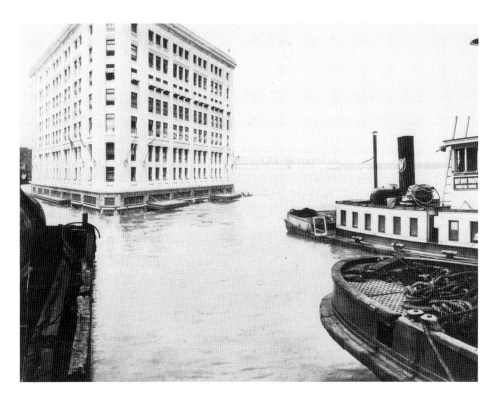

Although the 1937 flood waters did not reach Main Street, that did not keep this little bit of trick photography from making the president of Lowenstein's New York parent company think that it had. During the flood, the president sent a letter to the Memphis store instructing the management to stock up on candles and rubber boots, and if necessary, to build a levee around the building. For a reply, the executive received this photograph with the note, "It's too late."

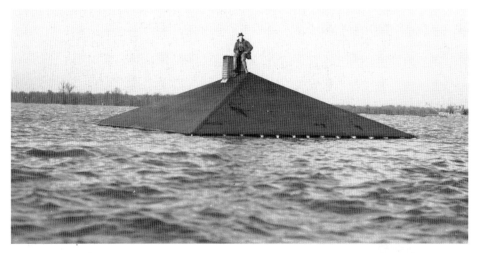

Although it is doubtful that this man is floating down the Mississippi while perched atop his house, it is apparent that the water has risen right up to the eaves of the house. Note the dredge in the background. Of all the times to be thinking about deepening the river, this one seems the most futile. It might have been used to break levees in an attempt to slow the rising flood waters.

four

Bridging the Mighty Mississippi:
The Frisco and Harahan

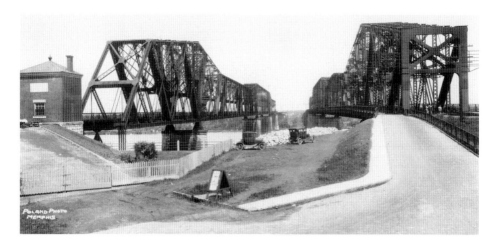

From the time of Native-American settlement and the French and Spanish explorations, people have struggled to cross the Mississippi River. When completed in 1892, the Memphis Bridge was the first to span the river south of its confluence with the Ohio River. Later known as the Frisco Bridge, this technological wonder provided easy access to the entire western half of the United States, and Memphians took advantage of the new rail connections and traveled to the West. Of greater importance to Memphis businessmen, the bridge provided access to a wealth of raw materials and markets in the West. The Harahan Bridge, completed in 1917, tripled the access of railroad traffic to Memphis. This added resource assisted Memphis in its continued growth as a transportation center. In addition to its two railroad lines, the Harahan had two roadways for wagons and automobiles; one was used for eastbound traffic and the other for westbound.

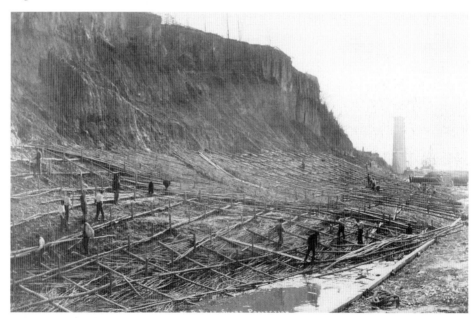

River erosion of the Memphis bluff caused some concern during the construction of the Frisco Bridge. In an attempt to deter the Mississippi's encroachment on the eastern bank, woven willow-mat revetments were made to keep the bank from washing away and undercutting the bridge approach. The mats weren't always successful and frequently had to be replaced.

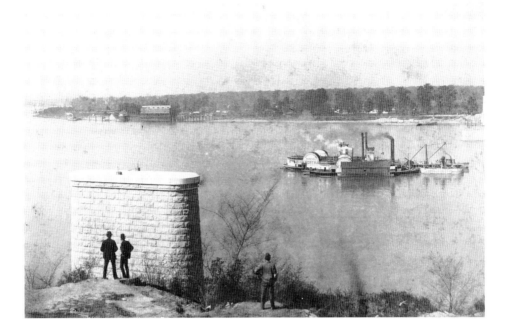

This photo shows Piers 1 and 4 completed, while Piers 2 and 3 are slowly rising above the water. The *John Bertram*, the *John F. Lincoln* (both owned by the Kansas City & Memphis Bridge Company), two tugs, and a covered supply barge are all clustered downstream from Pier 2, which is just emerging from the river's surface. On the West Memphis, Arkansas side of the river, the unusually shaped building is the coal elevator for the Kansas City, Fort Scott, & Memphis Railroad.

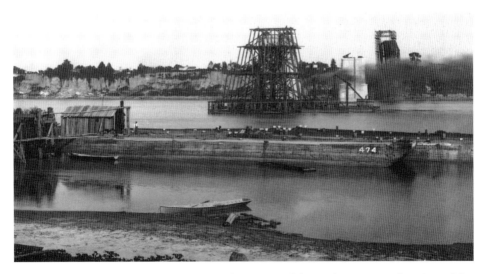

This view from the Arkansas shore shows simultaneous work being done on several sections of the bridge. The bridge's superstructure is beginning to extend from the Memphis side. The finishing touches are being made to Pier 3, which is blocked from view by scaffolding and two supply barges. In the foreground, two other supply barges lie near the Arkansas shore while workers scurry about on their decks.

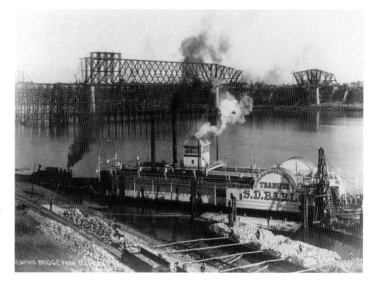

This photograph, more than any other, shows the importance of the Memphis Bridge. Prior to the construction of the bridge, small sections of trains were ferried across on special transfer boats such as the *S.D. Barlow*, a process that might take days to complete. After the bridge was finished, trains crossed in a matter of minutes. The semi-circular, crosshair sight on the bow of the *Barlow* was used to align the boat with the railroad tracks.

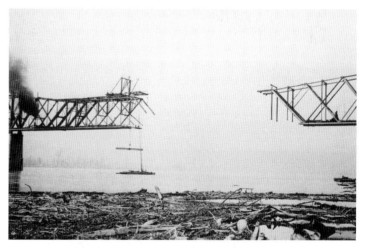

With the two outer spans completed, the middle span of the bridge gradually grew closer and closer together. A crane mounted on top of the superstructure was used to raise beams from supply barges on the river. Along the bottom edge of the photograph, a tangle of limbs and construction materials has formed a drift along the Tennessee shore.

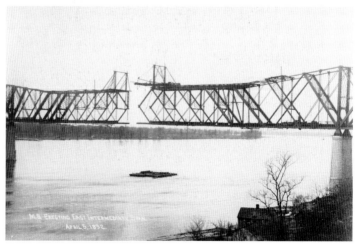

With the two sides almost touching, the crane now works on the Tennessee side of the bridge. This photograph was taken a mere month after the previous photograph. The height of the bridge narrowed in the central span so the bridge could bear the weight of the two sides until they were connected.

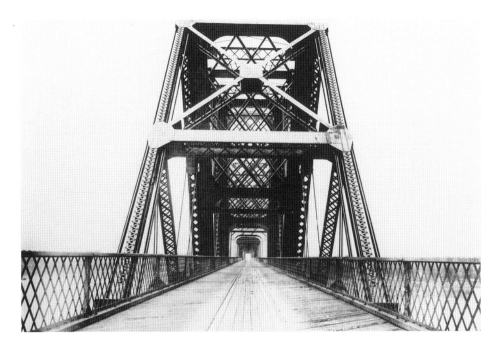

Upon completion, the bridge appears to be a tunnel on the far end. Close inspection is required to see the rails because federal law required all railroad bridges to be floored and open to vehicle traffic. Tolls were 50¢ for buggies and 75¢ for wagons. Even after being allowed to pass, a wagon was often overtaken by a train that crept along behind it until it cleared the track at the end of the bridge.

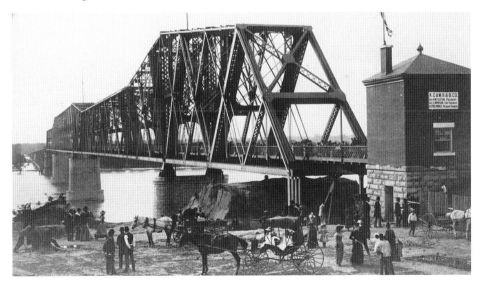

On May 12, 1892, the "Memphis Bridge," later known as the Frisco Bridge, opened for train travel. Fifty thousand people showed up to see what would happen when the first train crossed the bridge. Many believed that the bridge would collapse and send the train plunging into the Mississippi River. In this photo, the bridge is covered with people while the more timid stay safely on the bank.

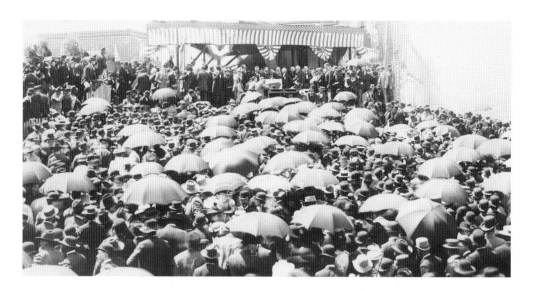

The opening day of the bridge was one of grand speeches with mayors, governors, and senators sharing the podium and platform. The crowd listened to the oratory in the hot sun while waiting for the main attraction, the crossing of the bridge. Although men outnumbered women in the crowd, several women can be seen on the left side of the stage. Umbrellas provided shade for the women in the crowd.

The climax of the day was the test of the bridge's strength. The test required 18 locomotives, all joined together, to slowly cross the bridge and stop in the middle of each span while measurements were taken to determine how much each would give or settle. Because of the perceived danger, each train was manned by volunteers. One engineer got cold feet at the last moment but a replacement was quickly found. After crossing to the Arkansas side, the train of engines returned at full throttle, reaching a speed of 65 miles per hour.

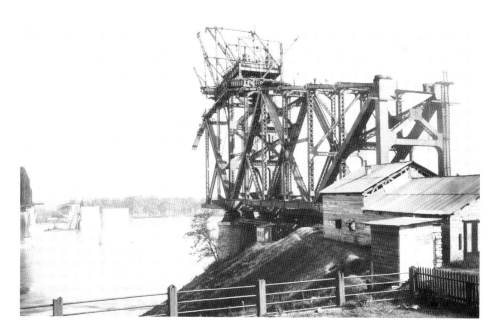

Construction on Memphis' second railroad bridge, the Harahan Bridge, began in 1913. The bridge piers were finished by January 1915, but the military's demand for steel during World War I held back work on the superstructure until April of that year. This photo of the bridge work, as seen from the Tennessee side, was taken during the summer of 1915. Although it can only be seen with a magnifying glass, a sign next to the upraised windows of the building reads "Danger! Keep Out!"

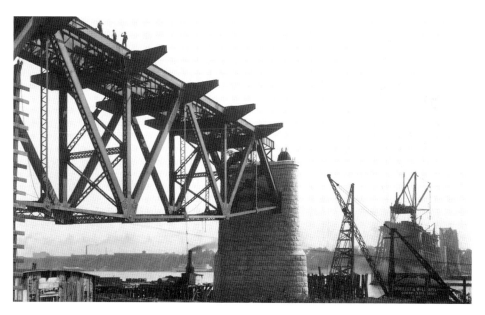

This photo, taken from the Arkansas shore, shows work beginning on the central span of the bridge, where the crane is located. The bridge section on the Tennessee (far) side of the river extends halfway to the central span. Once the central span was finished, the other half of the Tennessee section was completed from the central span.

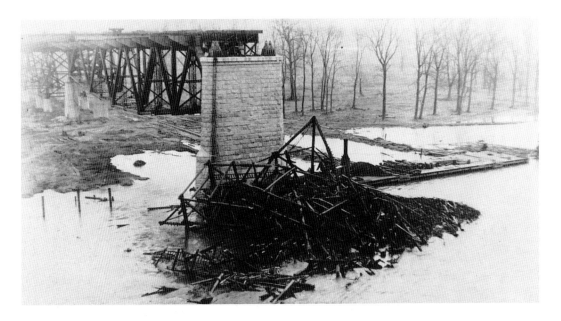

The construction of the bridge suffered a huge setback on December 23, 1915, when high waters carried away the supports and 500 tons of steel beams that were being assembled on the span nearest the Arkansas shore. This jumble of steel and wood against Pier 4 is all that remained of the section that was already more nearly complete than the central section shown in the previous picture.

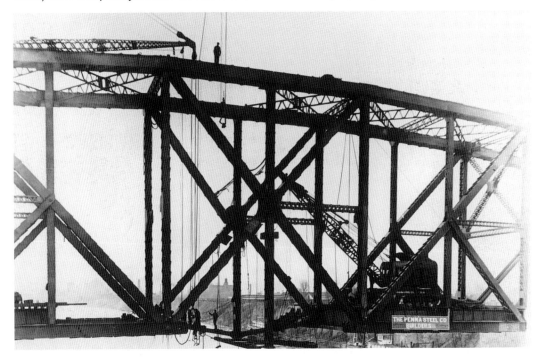

Despite the problems with high water, the Tennessee span was completed in April 1916, as shown above, and the Arkansas span was completed three months later. If you are afraid of heights, don't look at the man on the top of the bridge.

The Harahan Bridge opened to rail traffic on July 15, 1916, but with none of the hoopla that greeted the opening of the Memphis Bridge. The new bridge was wide enough to accommodate two sets of rails side by side. During World War I, two armed military guards were on duty to protect the bridge from sabotage. The other two men appear to be railroad employees, probably signalmen or switchmen.

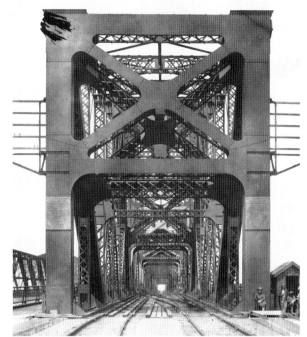

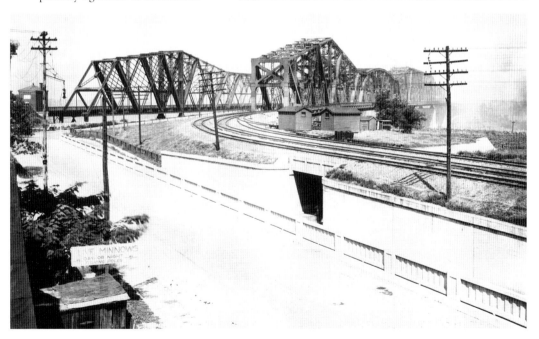

Although the roadways on the Memphis side of the Harahan were completed as part of the bridge, the new bridge was not initially used by wagons and automobiles because the Arkansas approach had not been built. This lack of traffic appears to have taken its toll on the small bait shop (bottom left). Although it advertises "Live Minnows" and "Day or Night Fishing Poles," the door is closed.

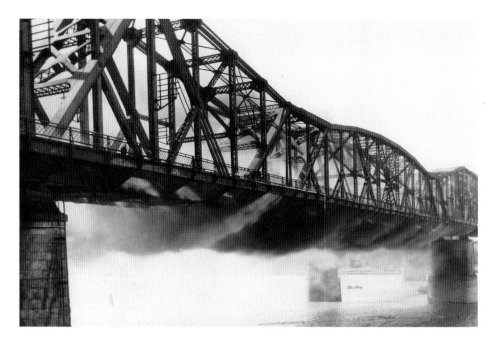

In 1928, the Harahan's wooden roadways and railroad ties caught fire, causing close to $1 million worth of damage. Although the wooden sections were replaced with steel, the railroad also hired special watchmen to keep a 24-hour lookout for fires. This photograph shows firemen attempting to extinguish the smoldering remains of the roadways. In places the wood has completely burned away, and the sun is shining through the holes.

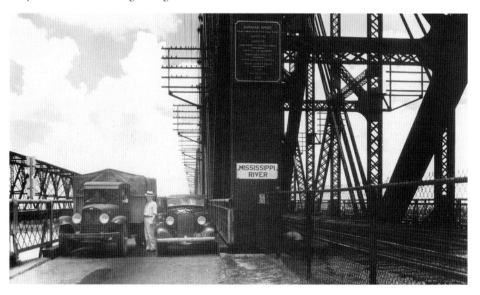

Because the Harahan was the only vehicular bridge between Cairo, Illinois, and Greenville, Mississippi, within 20 years of its construction traffic jams were frequent. The signs on the post (left) show that at least four U.S. highways crossed the bridge in 1935, and it was estimated that 10,000 to 12,000 vehicles crossed the bridge each day. In the short time the photographer needed to take this picture, traffic coming from Arkansas had begun to back up.

five

Memphis:
Transportation Hub of the Mississippi Valley

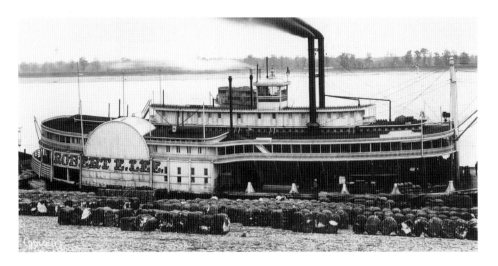

From its establishment in 1819, Memphis has been an important transportation center for the Mid-South and Mississippi River Valley. The city's location on the Mississippi made it the ideal port between St. Louis and New Orleans. From earliest days, river trade has progressed from flatboats to steamboats to barges. The steamboat is the icon of river transportation. This photo of the *Robert E. Lee*, with smoke drifting out of her funnels, shows the majestic proportions of the 19th- and early-20th-century steamboats. By the advent of the Civil War, Memphis was already connected to the rest of the United States by four rail lines, including the Memphis & Charleston Railroad, the South's only line connecting the Atlantic Ocean to the Mississippi River. Great bridges have provided continued growth for the network of highways and railroads that criss-cross through Memphis. Many large trucking firms have hubs in Memphis to take advantage of its central location. The enthusiasm of Memphis' early aviators brought an important dimension to the city's role as a transportation center. World War I and World War II military bases, the development of an international airport, and the creation of FedEx have strengthened that role.

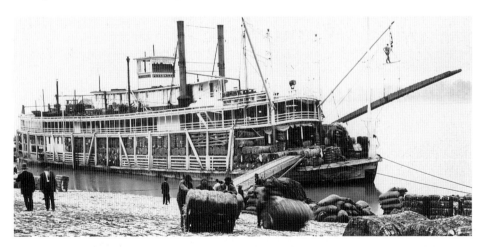

The lower deck of the *Peter's Lee*, another Lee Line boat, is solidly packed with cotton bales. In this view, cotton is being unloaded by rolling it down the gangplank and up the cobblestones. Because of their unwieldy size, rolling was an easy way to move cotton bales from place to place. The upper deck of the *Peter's Lee* holds a hodge-podge of wagons and disassembled farm implements. Note the boat hand balancing on the gangplank boom at the front of the boat.

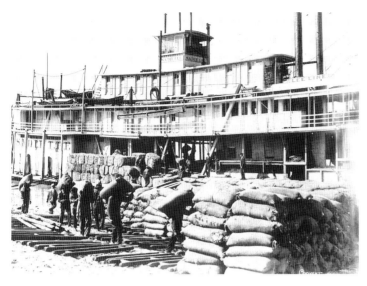

The *Sadie Lee*, like her 30-plus sister boats, was owned by the Lee Line. Bags of cottonseed are being unloaded and stacked on skids on the levee. Later, they would be transported to mills for processing into cottonseed oil and other products. Note the coal bunker between the two men (to the right of the gangplank).

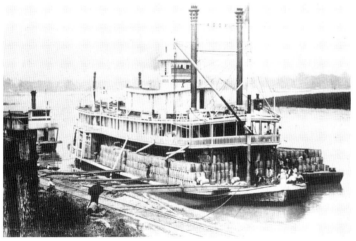

The Lee Line steamer *Lady Lee* and the barge next to her have a payload of wooden barrels. Because of the hardwood timber industry in Memphis, several local firms did a thriving business in barrel manufacturing. These firms provided barrels both for export and for use by area firms as shipping containers for merchandise.

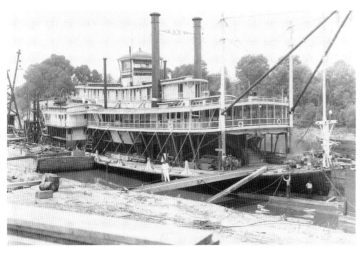

The *Kate Adams* was one of the most beloved passenger boats on the Mississippi. Her elaborate fittings made her a popular passenger vessel, particularly on yearly excursions to Mardi Gras in New Orleans. The metal-hulled boat was re-fitted in 1926 to be used in the movie *Uncle Tom's Cabin*. The ladders, boards, and sawhorses on the main deck appear to indicate that she was being re-fitted at the time this picture was taken.

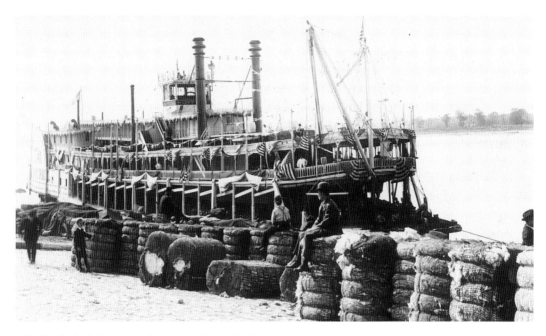

The flag-bedecked *Saint Paul* appears to be ready for a party or excursion. All the decks are covered with chairs. Most of the crew seem aware that a photograph is being taken, but those lounging on the cotton bales waiting for the festivities to begin seem oblivious to the camera.

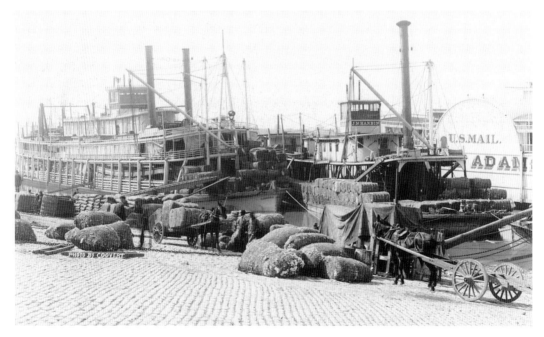

At times, the Memphis waterfront was packed with steamboats. Here the *Ferd Herold, J.N. Harbin,* and *Kate Adams* sit side by side. Each boat has a distinctive feature. The *Herald's* large search light helped night navigation. The *J.N. Harbin* only had one funnel. The *Kate Adams* served as a U.S. mail packet. Note the heavy chains attaching the wharf boat (far left) to the cobblestones.

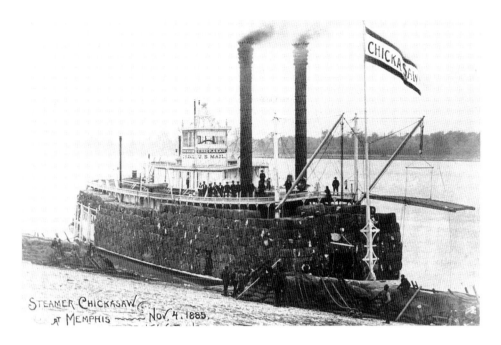

In this view are 1,613 bales of cotton—on one boat! Boat captains competed with each other in an attempt to do one better than their competitors while still maximizing their per-bale revenue. Although elaborately decorated, this image of the *Chickasaw* gives a true impression of the workhorse role most boats played on the river.

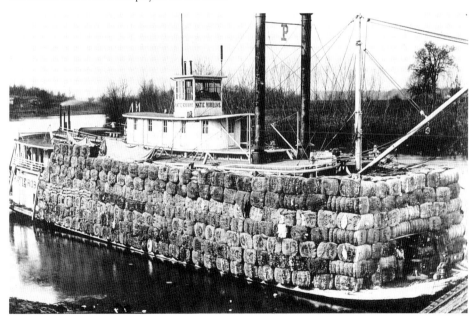

In this image of the *Katie Robbins*, the boat is stacked with so many cotton bales that her main deck appears to sit at water level. Notice the small tugboat guiding the boat from the rear. The "P" between her funnels indicates that the boat was operated by the Parisot Line.

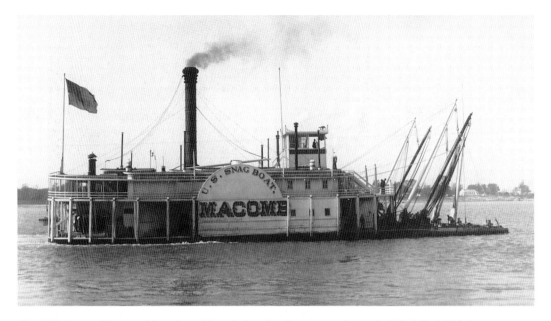

The U.S. Corps of Engineers' snagboat *Macomb* played an important role on the Mississippi. This boat, and others like her, patrolled the river looking for floating logs, submerged stumps, and fallen trees, which created hazards for the other boats on the river. The booms and pulleys on the front of the boat and the split-hull design allowed the boat to straddle the obstructions, then lift and remove them.

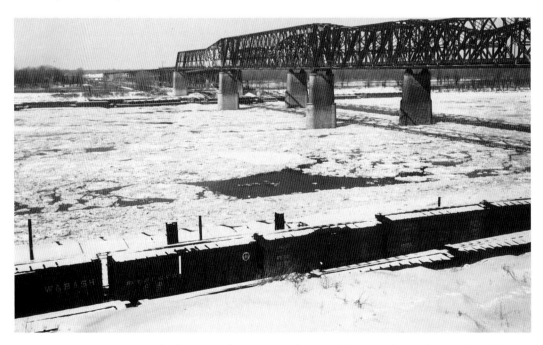

The Mississippi River at Memphis froze over three times in the period between the Civil War and World War II, each time wrecking havoc on river transportation. During the 1872 and 1918 freezes, hundreds of steamboats were crushed and sunk as masses of ice moved down the river. Freezing weather in 1940 brought barge traffic to a halt, as shown in the above photograph.

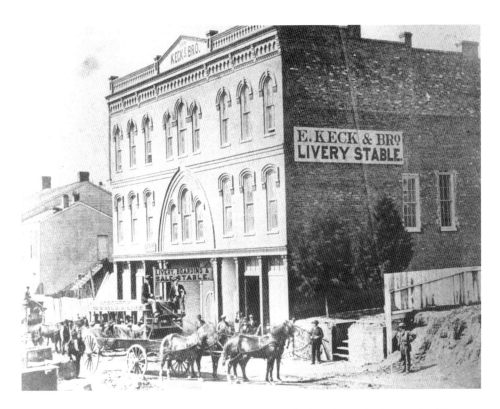

Prior to the building of streetcar lines, most Memphians relied on horses for longer trips. The livery stable of Keck & Brothers provided a place for boarding horses when they weren't in use. The photo also shows two coaches whose signboards indicate they were owned by a railroad line. These horse-drawn coaches provided quick transportation for people not yet on the city's rapidly expanding rail lines.

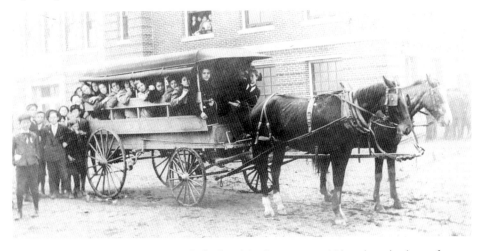

"Please keep your hands inside the bus." This bus driver's request would have been hard to enforce on Shelby County's first school bus. Because of the distances traveled by students in rural areas, Messick High School operated this bus to take students to and from school. One of the students in this picture is Jack Ramsay, who later became the chairman of the Shelby County Commission.

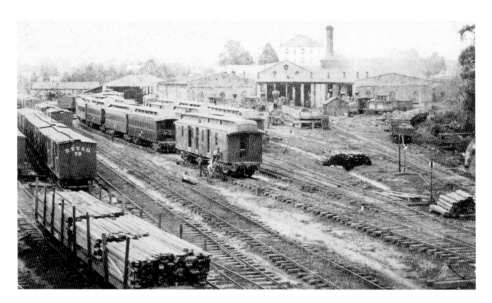

When the Civil War began in 1861, Memphis had four rail lines leading to and from the city, one in each direction. These were the Memphis & Charleston, the Memphis & Ohio, the Memphis & Little Rock, and the Mississippi & Tennessee Railroads. Of the four, the Memphis & Charleston, whose yard is pictured here, was by far the most important. This photo shows hardwood lumber on a flatcar, with cattle cars on the next siding. Workers are servicing a row of passenger cars, while engines are clustered near the roundhouse.

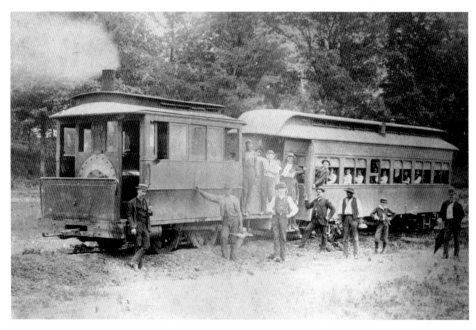

In the 1880s and 1890s, the Prospect Park & Belt Railway ran south along Hernando Road from Beale Street to Nonconnah Creek. As suburban Memphis grew, dummy lines like the Prospect were needed to provide dependable transportation to and from Memphis. The steam engine shown here has been enclosed to make it look like a passenger car.

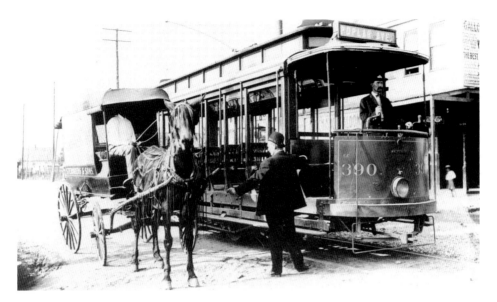

The photograph above shows the transition from horse-drawn carriages to new electric trolleys. The horse pulling the delivery wagon of Sternberg & Sons, Memphis' oldest tobacco wholesaler, wears a decorative leather harness. The corner saloon (upper left) advertises its $2-per-gallon whiskey as "the best on earth."

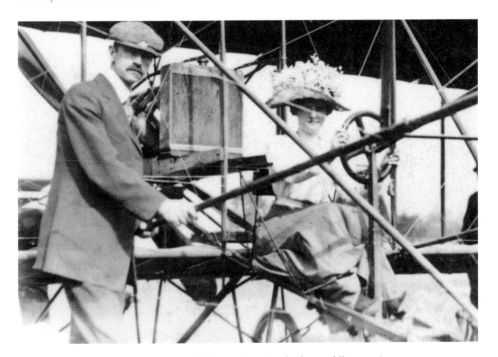

Seven years after the Wright brothers' flight at Kitty Hawk, the world's top aviators came to Memphis to put on a week-long air show. Among those in attendance were John Moisant, John Frisbie, and Roland Garros, whose plane crashed during the week. Flying from the Fairgrounds to the river and back, Rene Burrier won the 16-mile race in world-record time and claimed the $5,000 purse. This photo shows Glenn and Lena Curtiss posing with one of their planes.

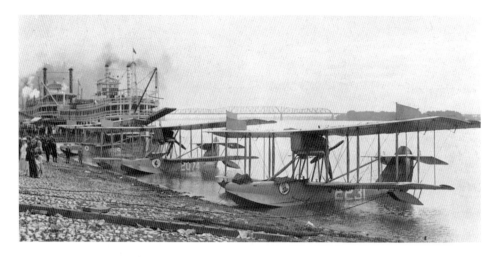

In this view, three World War I float planes have landed on the Mississippi River and are tied up at the levee. The squadron insignias on the planes are Uncle Sam's hat and a flying spade. With the railroad bridges and steamboats in the background, this unique photograph shows the rapidly changing mode of transportation from waterways to railways to airways.

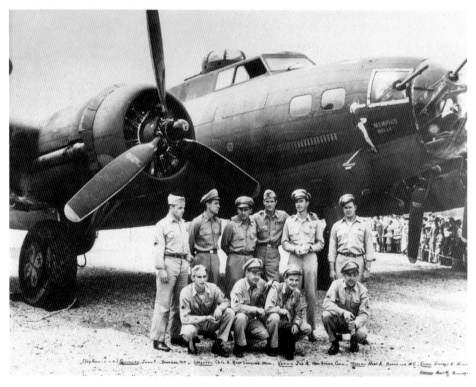

The *Memphis Belle* was the first B-17 Flying Fortress to complete 25 missions in Europe without casualties. To recognize this achievement, the plane and her crew were brought back to the United States to help sell war bonds. The plane was named for Memphian Margaret Polk, wartime sweetheart of Lt. Col. Robert K. Morgan, pilot of the *Memphis Belle*. Today, the restored plane is on exhibit at Mud Island.

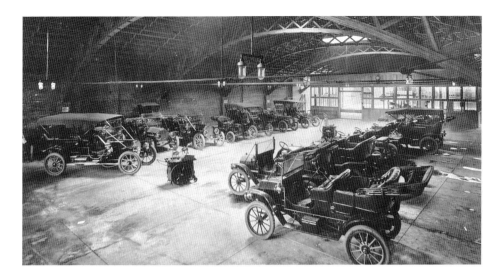

With growing ownership of the new makes of automobiles, mechanics at the Rockwood Garage on Madison Avenue were kept very busy. The arched roof of this spacious building, with its skylights and laminated wood trusses, make this building appear too nice for a garage; however, the two grease carts, the oil on the floor, and the "smoking positively prohibited" signs on the back wall clearly define its business.

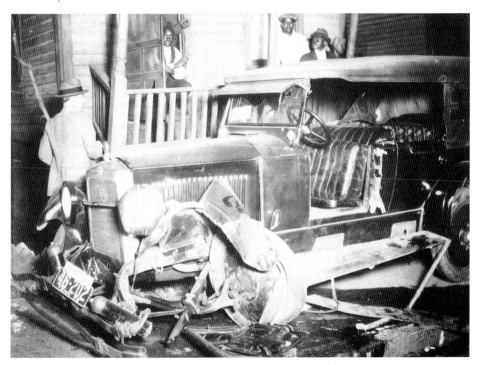

As automobiles became the major mode of transportation, accidents increased. In this view, an automobile appears to have been struck by another car or a trolley, which knocked it onto the sidewalk and into the frame house's porch. A pool of oil has leaked out over the sidewalk, the driver's door is missing, and the front seat has been folded up by the impact.

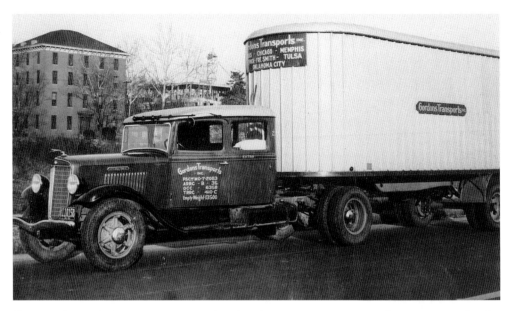

Because of Memphis' proximity to river, rail, and road transportation routes, trucking companies found the city to be an ideal location for their warehouses and terminals. By 1936, Gordon's Transports, a Memphis trucking firm, had a fleet of 50 modern trucks identical to the one shown. Christian Brothers College is visible in the background.

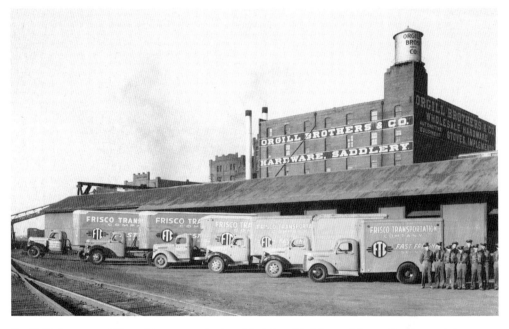

By 1940, there were 100 trucking companies based in Memphis. Many of these offered overnight delivery within a 300-mile radius; some, such as Frisco Transportation Company, offered free pick-up and delivery. Convenience and fast delivery caused trucking companies to diversify and find better and faster ways to deliver products. The Orgill Brothers' warehouse and the castellated towers of the Tennessee Brewing Company can be seen over the loading dock.

six

Busy Streets:
Downtown and
the Levee

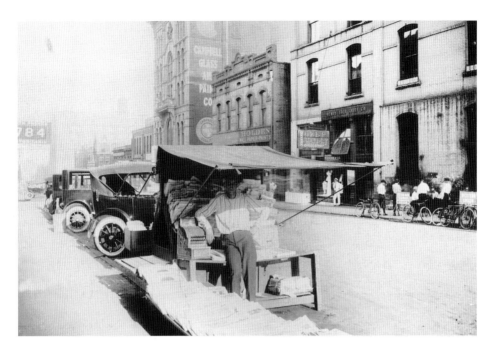

Although Memphis is today a large urban area with business and production centers dispersed throughout Shelby County, economic activity in the pre-World War II city centered around downtown and the levee. Much of the city's hustle and bustle took place on the boat landing or one of the downtown streets such as Front, Main, Second, or Third. Photographed in the morning, this view of Monroe Street shows a newsstand, a taxi stand, and various stores including Holden Wall Paper and Paints, Henry Loeb's Shirt Company and Laundry, and a Western Union office. Notice the telegram delivery boys with their bicycles. The newspaper headlines describe events of World War I.

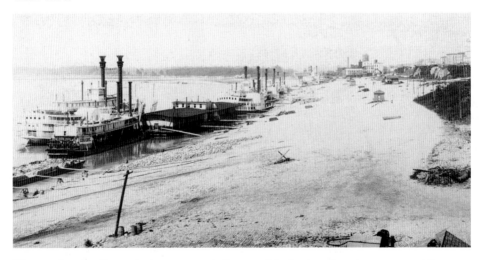

The steamboat landing at the levee was typically one of the busiest places in town, especially during the cotton season. Several parts of this image are interesting. Mud Island is not seen, as the sandbar island had not yet emerged from the river. Cobblestones were already in place as far south as the Beale Street Landing. The bluffs behind the Customs House are still visible.

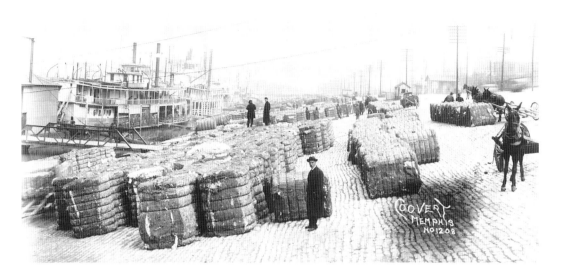

Cotton bales stacked on the levee were a common sight on the waterfront. Steamboats such as the Little Rock Packet Company's *Grand* are docked loading and unloading cotton. Cotton merchants walk on top of rows of cotton bales inspecting them, while draymen haul other bales to and from cotton warehouses.

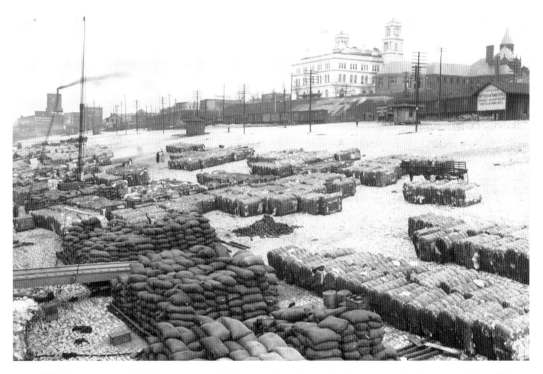

This shot, photographed from a cotton-laden steamboat, shows the levee covered with cotton bales and bags of cottonseed. The production of cottonseed oil and other seed by-products was an important part of the Memphis economy. The Customs House clock and the back of Cossitt Library are visible in the skyline.

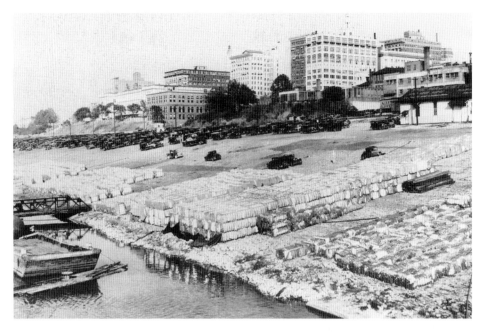

This picture shows the gradual changes in the levee over time. Due to the growing importance of automobiles, they began to compete with cotton bales for space on the levee. The Customs House towers are gone and Cossitt Library has a new addition. The Auditorium, Columbian Mutual Tower, Falls, D.T. Porter, Shrine, and Sterick Buildings have all been added to the skyline.

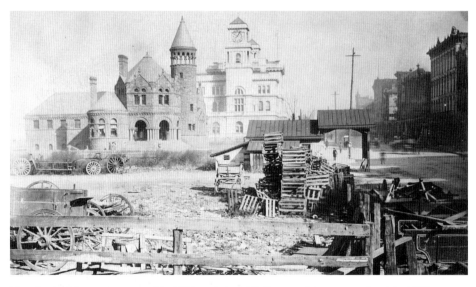

The Cossitt Library, constructed in 1893, and the U.S. Customs House, completed in 1885, were two of Memphis' most beautiful buildings. The sandstone, Romanesque castle, built to house the public library, was funded by the family of Frederick H. Cossitt, a prominent Memphis and New York businessman. The Italian villa-style Customs House next door served as a U.S. courthouse and, later, as Memphis' main post office. The rubble-filled lot (foreground) was eventually landscaped and became the site of Chickasaw Park.

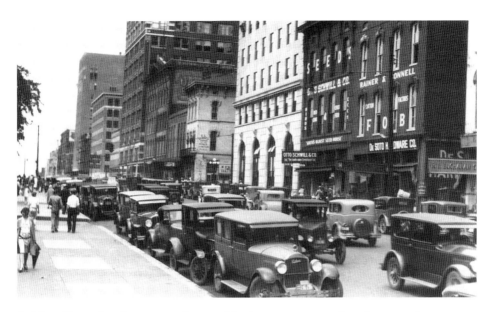

As Memphis continued to grow and automobiles became more prevalent, downtown became more and more congested. In the block opposite the Customs House and post office, some of Front Street's typical agricultural businesses can be seen. Notice the R.B. Buchanan Seed Company, DeSoto Hardware, and Otto Schwill & Company, the "South's Oldest Seed House." Seed and hardware stores were typically interspersed with cotton factor's establishments. The white building is Union Planter's National Bank, which has maintained close ties to Memphis' agricultural roots.

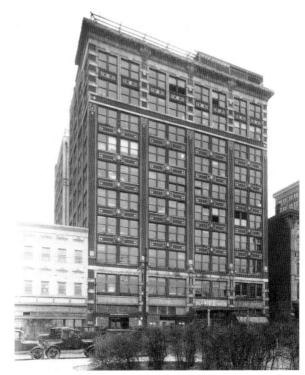

The Falls Building at 20 and 22 North Front Street was completed in 1912 as a high-rise office for cotton factors. The large windows were designed to provide light for cotton classing. The building was named for J. Napoleon Falls, one of the pioneers of the cottonseed oil industry. The building's unique list of firsts includes Memphis' first rooftop club, the Alaskan Roof Garden, where W.C. Handy premiered his "St. Louis Blues," and, in 1914, the first radio broadcast of a baseball game. The latter feat was achieved by the Tri-State Wireless Association, one of the building's tenants.

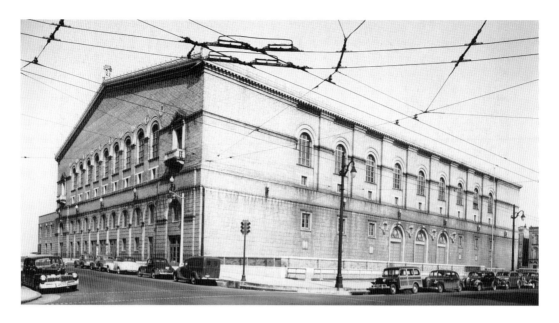

The Market House Auditorium, renamed Ellis Auditorium, was built between 1920 and 1924. The original designer of the "Italian Renaissance Barn" was George Awsumb. Although the building originally contained a farmer's market, its main attractions were two auditorium halls that shared a common stage. The auditorium has been the forum for everything from ballet, opera, orchestra, and theatre productions to professional wrestling and some of Elvis Presley's early concerts.

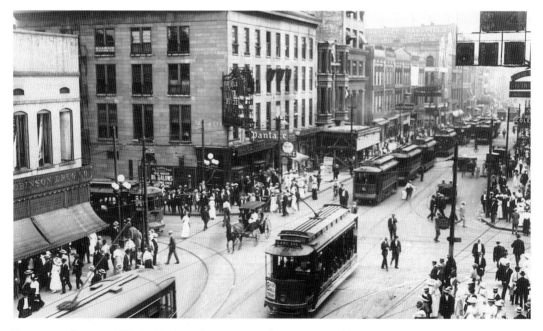

Fourteen trolleys are visible in this shot of Main Street where it is crossed by Madison, in the heart of the business district. The sidewalks and streets are crowded with people shopping and waiting for trolleys. Several signs advertise "Baseball Today" in the photograph dated August 5, 1912. Stores of interest include the Robinson Drug Company, Pantaze Drugstore, Brodnax Jewelers, and EEE $4 Shoes (top right).

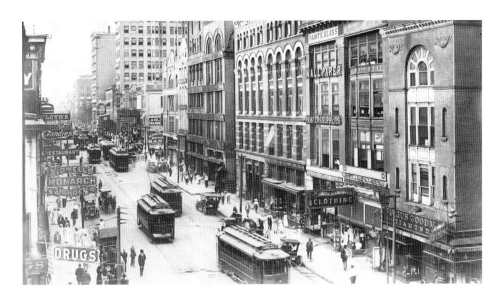

Although Main Street is less crowded with people in this view, taken a couple of weeks later, there are still 12 trolleys visible and many more horses and cars. Businesses include Julius Goodman Diamonds, Blue Ribbon Clothing, the Memphis Queensware Company, and Tidwell's Monarch Shoes. A restaurant and candy company are seen on the left. Note the women's long, white dresses and the men's straw hats in this summer scene.

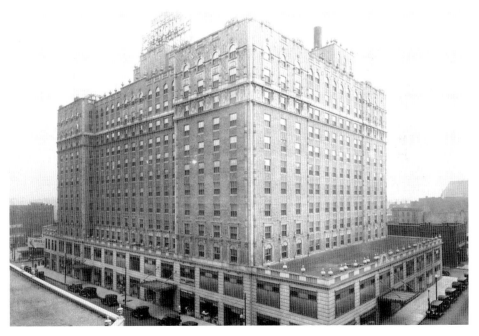

In 1935 historian David Cohn wrote, "The Mississippi Delta begins in the lobby of the Peabody and ends on Catfish Row in Vicksburg." The elaborately furnished Peabody Hotel with its ballrooms, fine shops and restaurants, and the Plantation Roof has long been known as the "South's Grand Hotel." The Peabody, shown in this photograph, was built in 1925. The original Peabody, constructed in 1869, was located at Main and Monroe Streets.

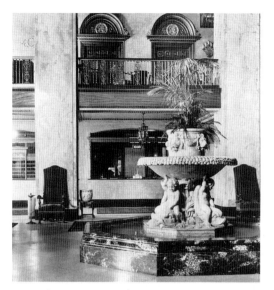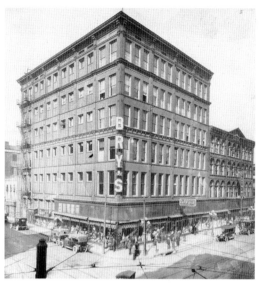

Above, left: The centerpiece of the Peabody Hotel is
the lobby with its Spanish-Moorish detail and Travertine fountain. A uniquely rural charm was added to the lobby in 1932, when the hotel manager placed some ducks in the fountain. The tradition grew and now visitors line up daily to see the ducks ride the elevator down from their roost every morning and waddle across a red carpet to the fountain. After a complete renovation by Belz Enterprises, the "grand old dame" reopened in 1981 and continues to serve as the focal point of Memphis' social activity.

Above, right: This 1918 photo shows Bry's, one of the South's largest department stores. The store was started in Memphis in 1902 by Nathan and Louis Bry and E.D. Block. Notice that Bry's Men's Clothing Store (right) is separate from the main store. Bry's anchored the north end of the Main Street shopping area, while Goldsmith's anchored the south end.

Opposite, above: The founding of Goldsmith's Department Store is a Memphis success story. Opened on Beale Street in 1870 by Jacob Goldsmith and his brother Isaac, the general merchandise store grew rapidly, moving or expanding three times by 1895. In 1902, the company moved the entire store across the street on a suspension bridge in just two days to the location shown in this photograph. The store's progressive spirit is also seen in their installation of the South's largest air-conditioning system in 1931 and the introduction of the metal charge card to Memphis in that same year. Eventually, the store's expansion covered an entire city block.

Opposite, below left: When the city of Memphis was first laid out, four public squares (Market, Exchange, Auction, and Court) and the riverfront were dedicated by the founders for perpetual public use. Early in its history, a meeting house/school and a fire station were built on part of Court Square. Over the years, early attractions in the square included a makeshift zoo, a bust of Andrew Jackson, the bandstand, and Santa Claus' hut. The centerpiece of Court Square is the cast-iron Hebe Fountain, which was added in 1876. The statue of Hebe is a copy of the Conova statue in Leningrad. The pool around the fountain was once 10 feet deep. At various times, it was used as a pond for goldfish, catfish, and alligators.

Opposite, below right: The D.T. Porter Building was Memphis' first skyscraper. Originally built in 1895 by the Continental Bank, the building was bought by Porter's heirs as a tribute and a monument to the former Taxing District president. At the time it was constructed, the building had a highly advanced heating system and one of the first elevators in the South. People paid 10¢ to ride to the roof and take in the view.

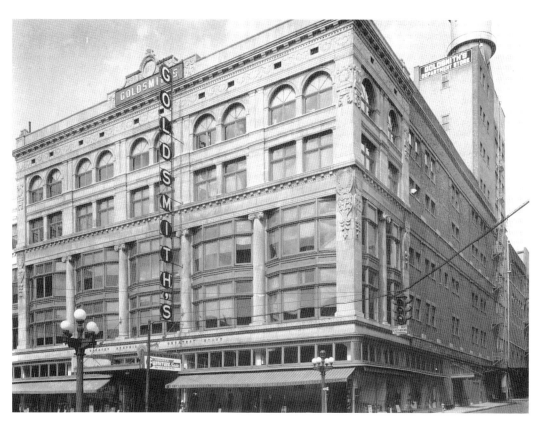

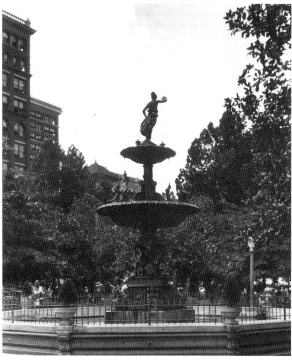

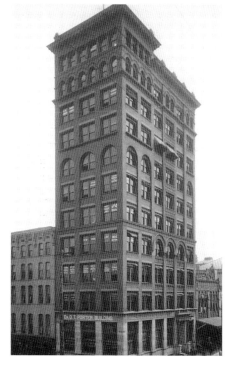

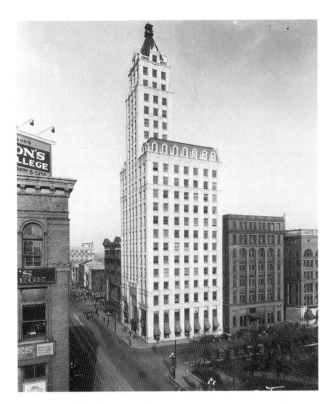

The Columbian Mutual Tower was constructed at the northwest corner of Court Square in 1924. The building's architectural style draws heavily on the Woolworth Building in New York City. Its observation tower provided a dramatic view of the Mississippi River, as well as Arkansas and Tennessee farmlands.

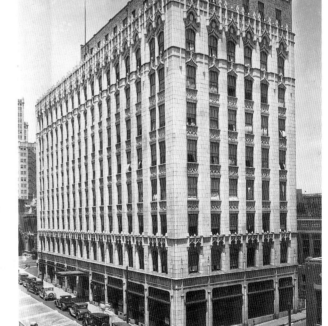

The Medical Arts Building, with its Gothic architectural details, was completed in 1926. The work around the windows and the spires on the building's roof makes this building one of the most captivating sights downtown. The building, located at 240 Madison Avenue, was the first modern Memphis building to provide office space primarily for physicians and dentists.

Right: Completed in 1930, the 29-floor Sterick Building, located at the corner of Madison Avenue and Third Street, was the South's tallest building at the time. Its name is derived from a combination of the names of the architect, Wyatt C. Hedrick, and his father-in-law and financier, R.E. Sterling. Note the Medical Arts Building at the corner of Madison and Fourth.

Below: The current Shelby County Courthouse was constructed 1906–1909 and represents a fine example of the City Beautiful Architectural Movement. Guarding the entrances to the building are majestic sculptures signifying Wisdom, Justice, Liberty, Authority, Peace, and Prosperity. On the far left is a portion of the architecturally similar Shelby County Jail and Criminal Court Building.

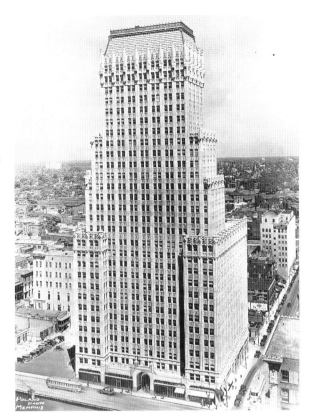

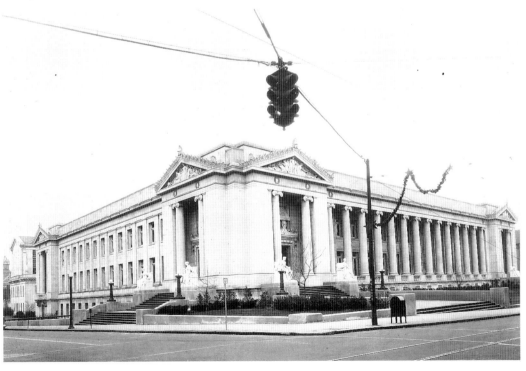

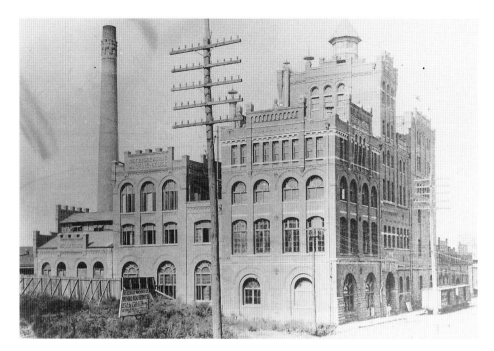

The Tennessee Brewing Company at 477 Tennessee Street was completed in 1890. It replaced the original building, which stood on the vacant lot next to the brewery. Although the segments vary in width and height, giving the building a look of multiple additions, a close look at the detail work reveals the similarity of the parts. At the top of each section's facade, blockwork letters describe the functions: "Brew House," "Refrigerating Machine House," and "Boiler House."

If you need something to drink, "Just Whistle." Memphis had dozens of small beer and soft drink bottling companies. Pictured here is the entire staff of the Whistle Bottling Company at 303 South Main Street. The view includes a wooden doll sitting in a chair atop the center truck. The business was short-lived, closing its doors in 1922, three years after it opened.

seven

The City Grows:
Architectural
Snapshots

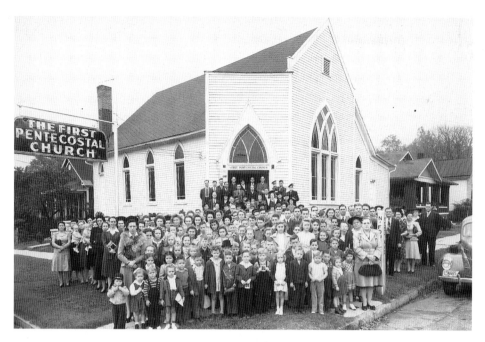

Architectural landmarks often tell as much about the people of the community as they do about architecture itself. Among the public buildings of Memphis, its churches employ the most diverse architectural styles, from simple clapboard buildings to grand structures in stone and marble. As the "buckle" of the Bible Belt, at one time Memphis was said to have more churches than gas stations. The plain architectural style of the First Pentecostal Church (shown above) reflects the rural roots of its members. Constructed of white clapboard, its arched windows provide light and identify the simple building as a church. The entire congregation posed for this photograph in 1943. Several children have Sunday school leaflets in their hands, and one smiling girl proudly displays her Bible.

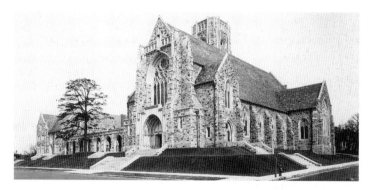

Sitting on an elevated site, the Idlewild Presbyterian Church is one of the city's most majestic architectural works. Designed by architect George Awsumb and constructed 1926–27, the building is an outstanding example of Gothic Revival style. It is built of stone from the same Arkansas quarries that supplied building materials for Rhodes College. The impressive complex of buildings includes the main church, cloistered walkways, a chapter house, and a massive bell tower that daily tolls the hour and each quarter of an hour. The interior features an imposing French Gothic nave with beautifully carved dark oak beams, tracery, and a choir screen.

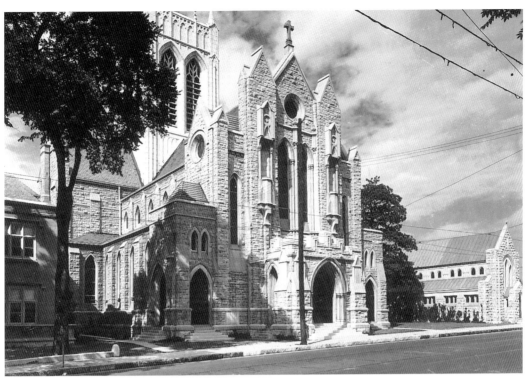

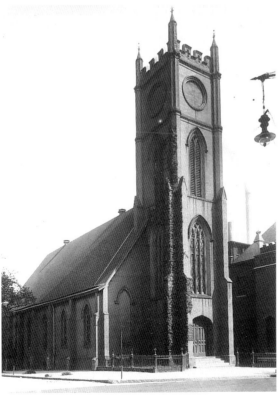

Above: One of the oldest cathedrals in the South, St. Mary's Episcopal Church was organized in 1856 as a mission of Calvary Episcopal Church. In 1866, Bishop Charles Todd Quintard designated St. Mary's as the Cathedral Church of the Diocese of Tennessee. The original church was a small, wooden, Gothic structure. The present Cathedral, dedicated in 1926, was built in several stages, with Bayard Snowden Cairns serving as the architect for its completion. The marble altar is a memorial to the Episcopal sisters and priests who died in the 1878 yellow fever epidemic. The Sisters' Chapel (right) was originally part of St. Mary's School.

Left: Calvary Episcopal Church, organized in 1832, is the oldest surviving public building in Memphis. The present church, constructed in 1843, has been in continuous use since that time, and its doors have remained open through wars, epidemics, and urban change. Calvary has undergone several additions, including the 1848 bell tower and James B. Cook's 1881 extension of the east portion of the nave. The open, timbered interior, white walls, arched stained-glass windows, and dark pews convey the feel of an English parish church, heightened by the exterior of hand-made pink brick.

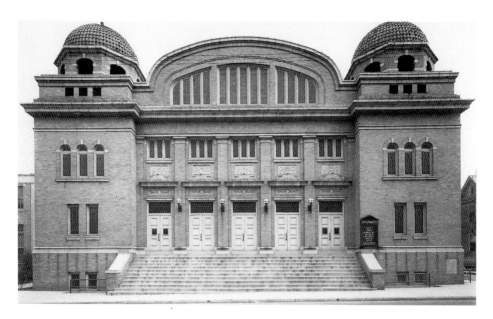

The Bellevue Baptist Church began in 1903 as a mission of the Central Baptist Church. The 32-member congregation first began worshipping in a small stone chapel. The sanctuary shown here had been enlarged by the time of this 1930 photograph. Following numerous additions, including a new sanctuary in 1952, the growing congregation, now one of the largest in the South, relocated to eastern Shelby County. Its former church complex is now home to the Mississippi Boulevard Christian Church. The sign board announces that Dr. Robert G. Lee will preach at both the 10:50 a.m. and 7:30 p.m. services. Dr. Lee was acknowledged as one of the finest pulpit orators in the South, and the church was packed whenever he preached his famous "Pay Day Someday" sermon.

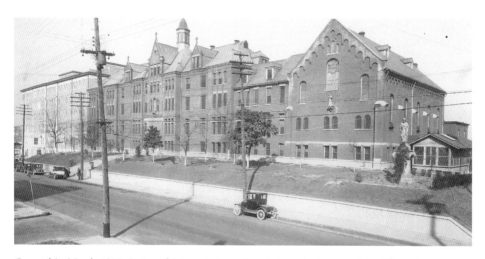

Opened in March 1889, St. Joseph's Hospital was founded by the Sisters of the Third Order of St. Francis, giving Memphis its first privately owned medical facility. The brick hospital shown in the photograph was built in 1895 and was considered very modern for its time. Although operated by a Catholic order, St. Joseph's Hospital always received much of its support from the Jewish and Protestant communities of Memphis. The large statue of St. Joseph, which stands near the hospital chapel in this picture, is now located in front of a newer building.

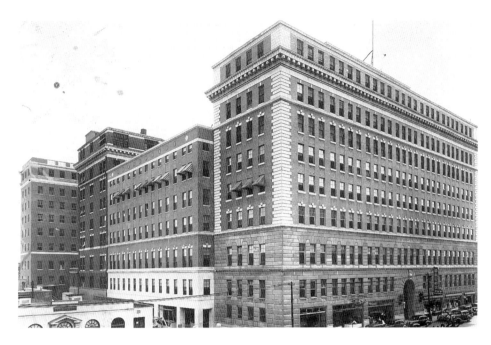

The Baptist Memorial Hospital was opened in July 1912 as a 150-bed facility; however, by 1937 several additions brought the bed capacity to more than 525. Soon after it opened, Baptist Hospital became allied with the adjacent University of Tennessee Medical School as a teaching hospital; it has grown to become one of the largest non-profit hospitals in the nation. This 1937 photograph shows the Physicians and Surgeons building. Designed to serve as a medical office facility, it was connected to the hospital. Visible behind the P&S Building, which fronted on Madison Avenue, are several hospital additions.

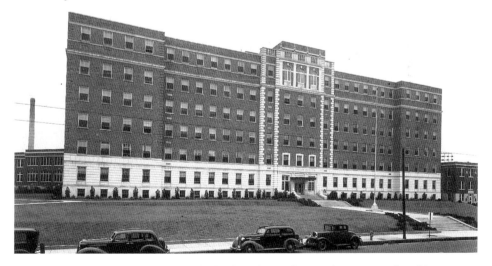

The Regional Medical Center at Memphis has been known by several names in its long history, including John Gaston Hospital. Built in 1936 as the third city hospital, John Gaston was named for a French immigrant and local restaurateur whose widow left $300,000 in her estate to provide partial funding for its construction. Located on Madison Avenue in the medical center area, John Gaston was the major teaching hospital affiliated with the University of Tennessee Medical Schools.

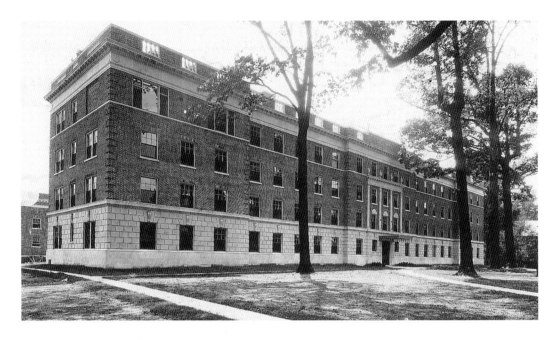

When the first Methodist hospital was completed in the fall of 1921, it was acquired some six months later by the Veterans Bureau as a hospital for World War I veterans. The second Methodist hospital (shown above) was built in classic, Georgian style; it opened in September 1924. Numerous additions to this site on Union Avenue, as well as the satellite locations in the Memphis area, have made Methodist Health Care Systems the largest local regional health care provider.

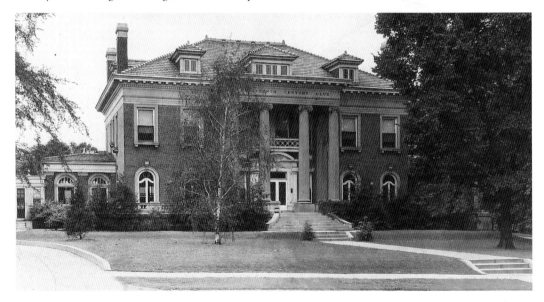

This impressive structure, home of the Nineteenth Century Club since 1926, was built on Union Avenue in 1909 as a residence for the family of Memphis lumberman Rowland J. Darnell. Founded in 1890, the club has played a leading role in the cultural, educational, and philanthropic life of Memphis. The Nineteenth Century Club was, at one time, the largest women's club in the South. It has provided leadership in many areas of civic progress.

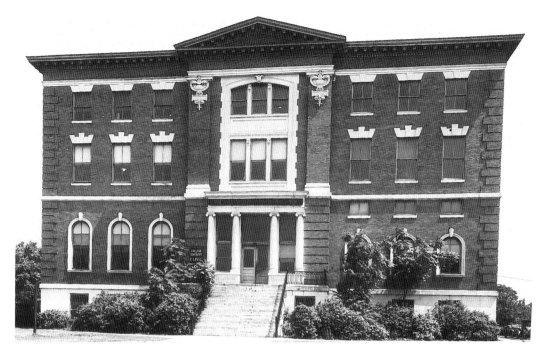

The University of Tennessee College of Medicine moved to Memphis in 1911, and over the next three years it completed mergers with four other medical schools, including the College of Physicians and Surgeons and the Memphis Hospital Medical College. These mergers, coupled with the growth of Memphis hospitals, made Memphis a regional medical center. Opened in 1902, Rogers Hall (pictured above) was the last and largest addition to the Memphis Hospital Medical College. It was named in honor of William D. Rogers, the school's founder and first dean. Following the merger with the University of Tennessee, the building became the College of Dentistry.

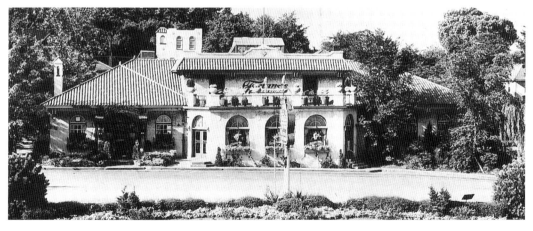

Fortune's Jungle Garden, the world's first drive-in restaurant, opened in Memphis at the corner of Union and Belvedere. Spanish architecture and lush landscaping were distinctive features of the restaurant. Harold Fortune, a drugstore operator and founder of this "first," provided curbside service to his downtown customers in 1906. Advertisements urging customers to honk twice for "Fortune's auto soda service" caused such traffic jams that police objections forced him to move. Fortune also manufactured ice-cream that was in high demand in the Memphis area.

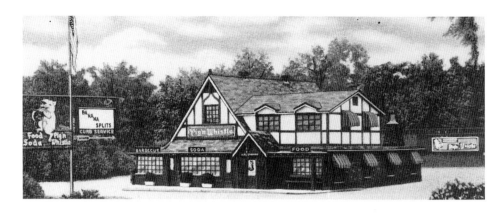

Although Memphis had three Pig'n Whistle Restaurants, when the young adults who frequented the drive-ins said "meet me at the Pig," 1579 Union Avenue was the understood destination. Opened in 1926, this popular gathering place, with its sign of the dancing pig, was noted for its friendly service and good food. The Pig's long-tenured car hops knew the names of many customers, and Elvis Presley and Dewey Phillips were sometimes part of the late-night crowd. Popular waiters were known to the customers by nicknames such as "Preacher," "Cadillac," and "Redwood." The waiters also created a colorful lingo for food items such as "palm beach" for a pimiento cheese sandwich, "muddy goo" for a frosted chocolate malt, and "stretch" for a large Coke.

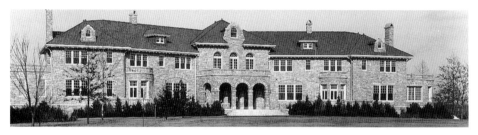

This mansion home of Clarence Saunders is much better known today as the Pink Palace Museum. Built in 1922, with Herbert T. McGee as the architect, the home at 3050 Central was never lived in by Saunders. After building the Piggly Wiggly grocery store chain from one store in 1916 to 1,200 stores in 1922, he lost ownership of both the stores and the house. The house was then given to the City of Memphis. The City opened it as a museum in 1930.

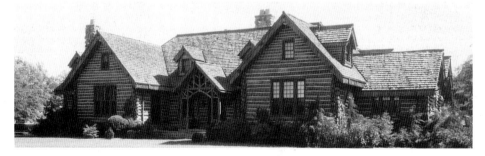

Clarence Saunder's second house also ended up as a public facility. His cypress log cabin estate, named Annswood for his daughter, was given to the City of Memphis by the family of Ira Lichterman. The Lichterman Nature Center is now operated as part of the Memphis Museums System. The log house, used as a welcome center, was destroyed by fire in 1994.

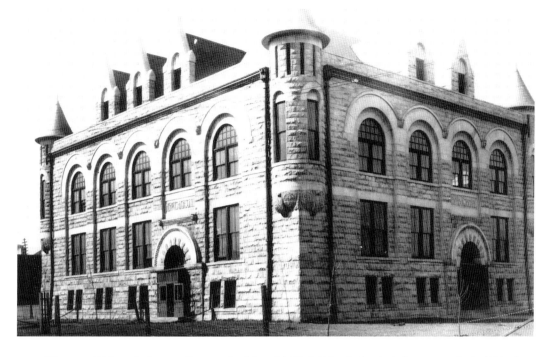

The year 1910 marked two milestones for Memphis High School, the city's first separately established public secondary school. The football team beat every high school it played and even played Ole Miss, though they lost the game 10 to 0. Also, the 33 seniors in the class were the last to graduate from the old turreted building, located on Poplar Avenue at Lauderdale. For many years thereafter, the building was used by the Memphis Board of Education. During urban renewal and the widening of Lauderdale the old high school was torn down.

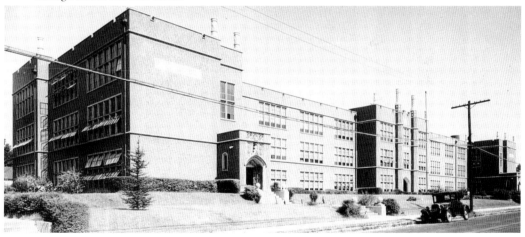

Elvis fans will recognize this photo. Humes High School was designed by George Awsumb and was, after its construction in 1924, considered a Memphis show place. Its eclectic architectural style featured a Tudor-Gothic doorway with buttresses ending in finials above the roofline. In the 1920s and 1930s, enrollment in the junior and senior high school was nearing 2,000 students. The building, constructed of fireproof concrete, featured an auditorium with a seating capacity of 1,200. In the days prior to air-conditioning, the windows swung open to provide maximum circulation on hot and muggy days.

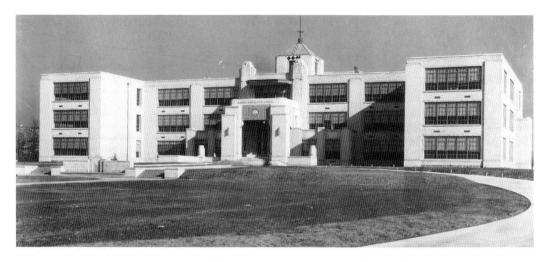

Poised at the top of a sweeping driveway, Fairview Junior High School, built in 1930, was one of the last Art Deco buildings constructed in Memphis. Situated on a 6-acre tract, the school faces tree-lined East Parkway at Central Avenue. The building features crisp, geometric lines with mosaic work and marble scrolls over the entrance. When the school opened in 1930, it featured state-of-the-art fire and disaster security in its all-steel and concrete construction. The school name was derived from its location adjacent to the Memphis Fairgrounds.

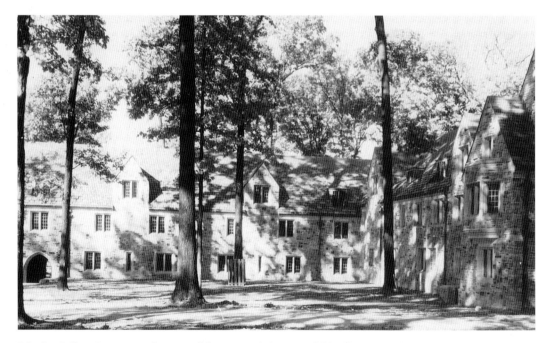

Rhodes College is recognized as one of the country's finest small liberal arts schools. Founded in 1848 in Clarksville, Tennessee, the school was moved to Memphis in 1925. Known as Southwestern at Memphis, the college was renamed in 1984 to honor longtime president Payton Nall Rhodes. Noted for the beauty and integrity of its Gothic architecture, the college is located on a forested 100-acre tract opposite Overton Park. To assure architectural uniformity of campus buildings, the college owns the Arkansas quarries from which the orange-brown stone is cut.

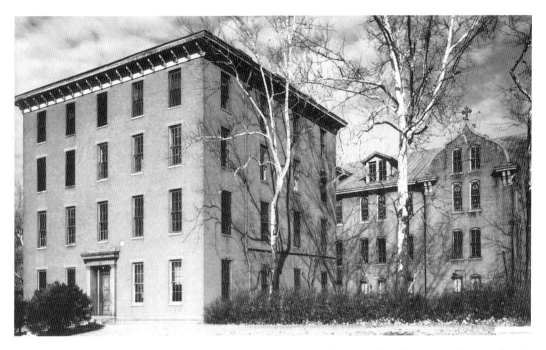

Christian Brothers College is Memphis' oldest college. Founded in 1871, the Christian Brothers purchased the Memphis Female College at 612 Adams Avenue, built in 1854. Shown behind the large sycamore tree is one of the 1880 additions. The college was closed for periods during both world wars due to loss of students. The large campus is now located at the corner of Central Avenue and East Parkway.

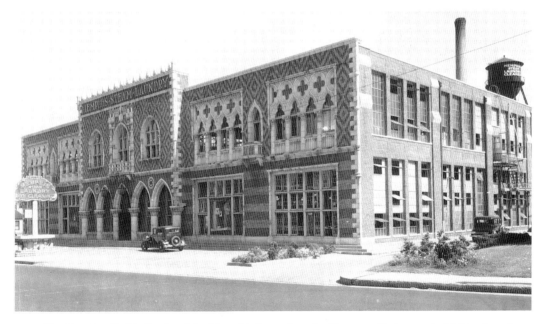

The Venetian-Gothic facade of the Memphis Steam Laundry Plant provided a wonderful false front for an industrial building. The detail of the work on the upper floor and entry contrasts sharply with the dry cleaning equipment seen in the second-floor windows.

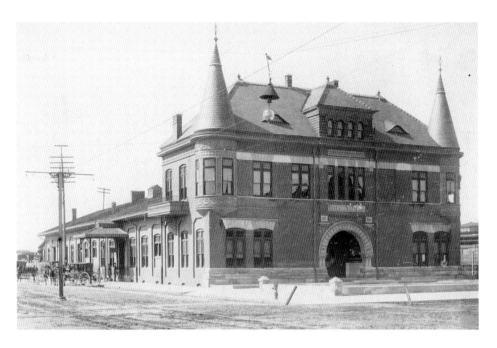

Most of the railroads that served Memphis had separate stations that were scattered around the city. Illinois Central, which had its Central Depot on Calhoun, refused to join the other railroads in the construction of Union Station and in 1913 built their own new Grand Central Station on South Main Street.

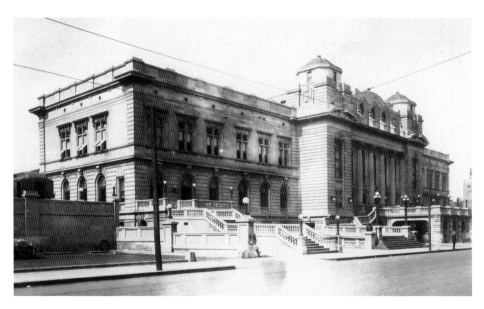

In 1912, all of the railroads with service to Memphis, except the Illinois Central Railroad, jointly built this elaborate Beaux-Arts station. A specialized feature of the station was the roundhouse, which backed all trains into the station. Note the passenger car above the retaining wall (left). The station was located at 199 East Calhoun Avenue, presently the site of the United States Postal Service Automated Handling Facility.

eight

Corner Stores and Corporations: Memphis Businesses

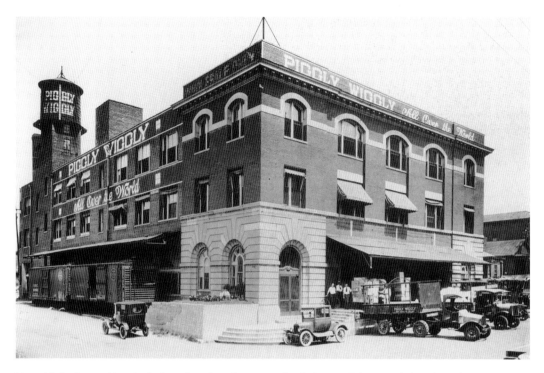

Memphis businesses historically have functioned on many levels. Some of the most beloved are the "mom-and-pop" corner stores and neighborhood hangouts. Memphis has been a point of origin for several innovative business ideas. With the organization of Piggly Wiggly, Holiday Inns, and FedEx, people all over the world now benefit from supermarkets, comfortable motels, and overnight delivery.

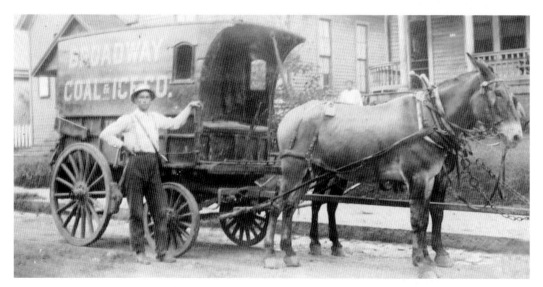

In an age before supermarkets and gas and electric transmission lines, many Memphians relied on delivery vehicles for their basic necessities. In the 19th and early-20th centuries, many businesses delivered to your doorstep. In this view, the Broadway Coal & Ice Company wagon is making a delivery. We hope they delivered the coal and the ice in separate vehicles.

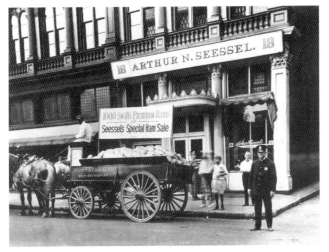

How many hams does it take to fill a wagon? The obvious answer would be the number in this wagonload of cured hams from Swift & Company. Swift's premium hams are being used as a promotion for Memphis' oldest family-owned grocery business. Seessel's, opened in 1858 by Henry Seessel, was owned and operated by the family until its recent sale.

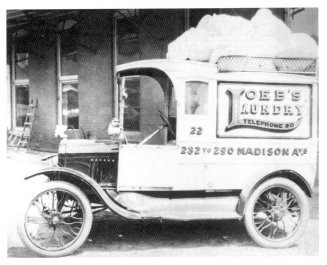

Another home-delivery based service in this period was laundry. Prior to the invention of household washing machines, laundry either had to be hand-washed or sent out to a commercial cleaner. Loeb's Laundry was founded in 1887 by Henry Loeb Sr. His business grew to include a haberdashery, a shirt factory, and a Turkish bath.

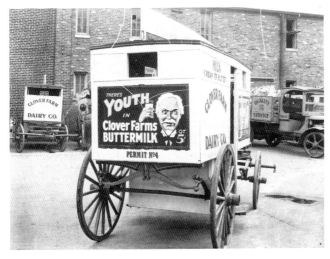

Supplying fresh milk to the doorsteps of thousands of Memphis homes and businesses was a difficult job. The Clover Farm Dairy, which occupied a block on Walnut Street between Union and Beale, kept an entire fleet of wagons and trucks for its morning deliveries. The wagon permit number was a local precursor to state license plates. The taillight was designed to make the delivery vehicle visible in the wee hours of the morning.

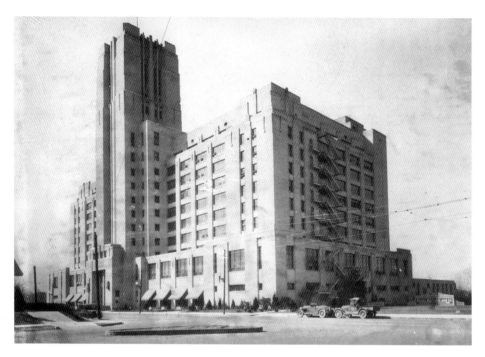

This Memphis landmark, built in 1927 at a cost of $15 million, was a commercial Art Deco design that covered more than 4 acres. On opening day, 47,000 people lined up to tour the new store. The flagship Sears and Roebuck store employed 1,000 Memphians in its retail and catalog divisions.

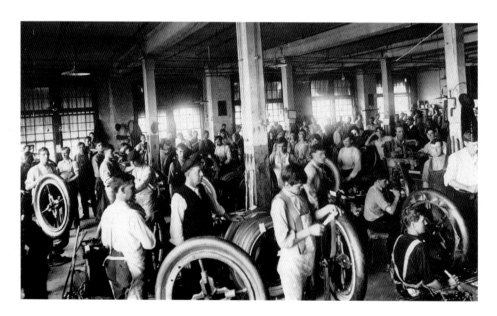

In 1936 the Firestone Tire and Rubber Company bought the plant of Murray Wood Products and converted the facility into a tire plant. Employing hundreds of Memphians, companies like Firestone, International Harvester, Ford, and Pidgeon Thomas made Memphis into a Southern center for manufacturing.

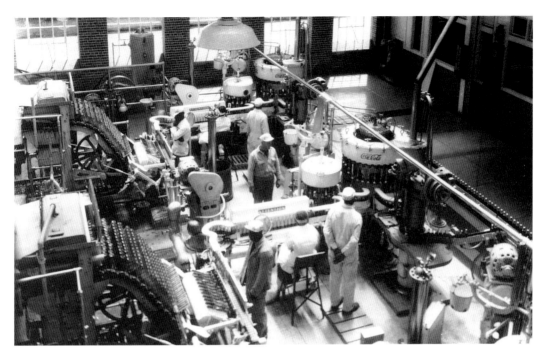

Although Memphis was home to numerous bottling companies, it was not until 1905 that James C. Pidgeon established the first Coca-Cola bottling plant in Memphis. In this view, two modern bottling lines are washing, filling, and capping reusable bottles under the watchful eye of several workers.

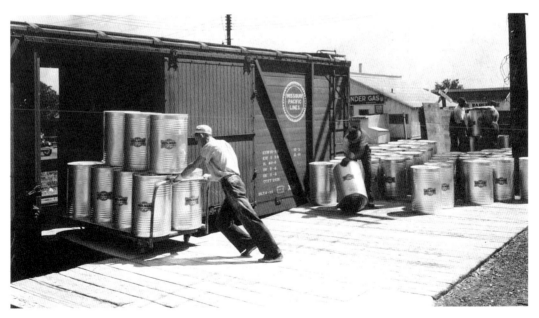

The city's location in a rich, agricultural region, along with its facilities for manufacturing and distribution capabilities, worked well for those companies with regional and national markets. The shipping department workers of the Commercial Chemical Company are shown loading a railroad car with calcium arsenate, a poison used to control boll weevils.

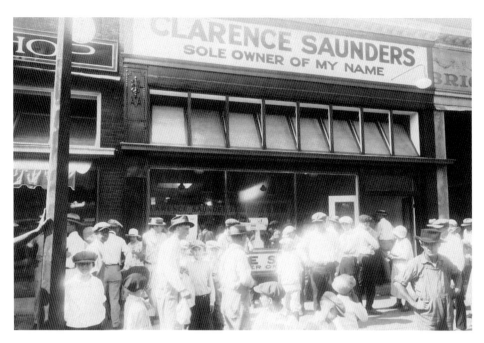

In 1916 the concept of modern supermarkets was born with the opening of Clarence Saunders' first Piggly Wiggly store. By 1922, there were some 1,200 Piggly Wiggly stores and Saunders was a multi-millionaire. That all changed in 1923, when he lost his business and personal fortune through stock manipulations on Wall Street. Undeterred by bankruptcy, Saunders successfully sued his former company for the right to use his own name and opened a chain of "Clarence Saunders, Sole Owner of My Name" stores in 1924. Bankrupt again by 1931, Saunders launched a campaign to make his third fortune in 1932 with another group of "Sole Owner" stores.

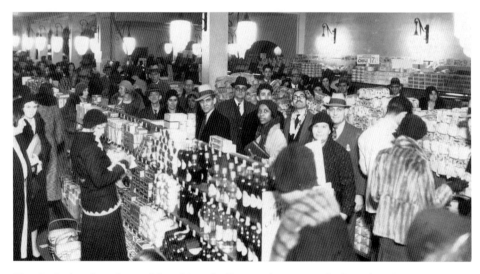

Here in the interior of one of those "Saunders" stores, shoppers are looking for a large selection and low prices. After World War II, Saunders started his fourth venture, the Kedoozle, a revolutionary vending-machine grocery store that had the bill totaled and groceries sacked by the time the customer got to the checkout counter.

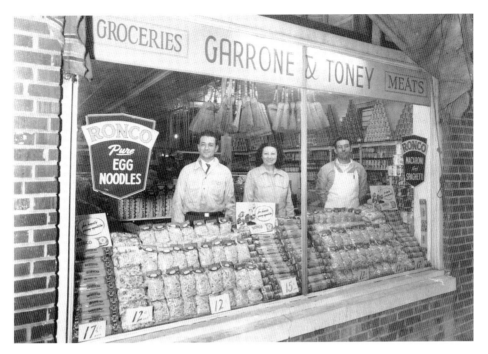

Italian immigrants began arriving in Memphis before the Civil War. Many became truck farmers, while others became associated with grocery and liquor businesses. Garrone & Toney, an Italian grocery store at 461 Beale Street, proudly displays noodles made by another Italian company in Memphis, Ronco Foods, today a nationally known brand.

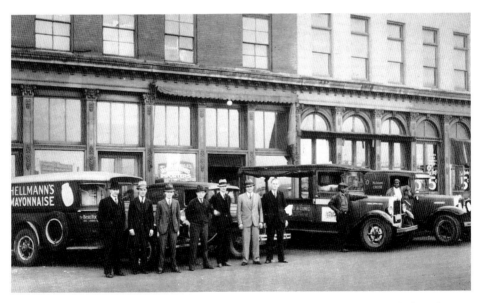

Some Memphis firms specialized in imported items. Robilio & Cuneo was one such firm; they distributed mushrooms, olive oil, cheese, and Hellmann's Mayonnaise. The Golden Eagle Sandwich Shop next door advertises traditional American foods such as "Hot Fish, Hamburgers, Hot Dogs, and Soft Drinks," each for 5¢.

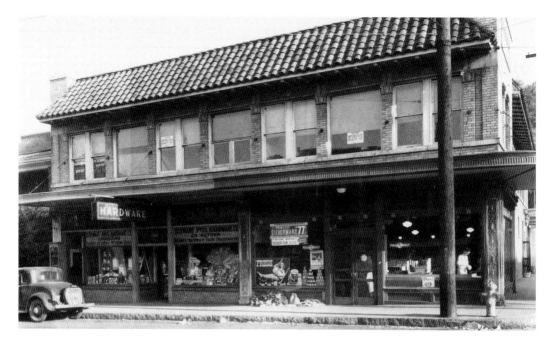

In most Memphis neighborhoods, the corners where major streets crossed were the centers of commerce. This photo of the northwest corner of the intersection of Madison and Cleveland features a restaurant, grocery store, and hardware store. The oldest of these businesses is Stewart Brothers Hardware. Opened downtown in 1887, Stewart Brothers moved to this Crosstown location in the 1930s. A dentist's office is located above the hardware store.

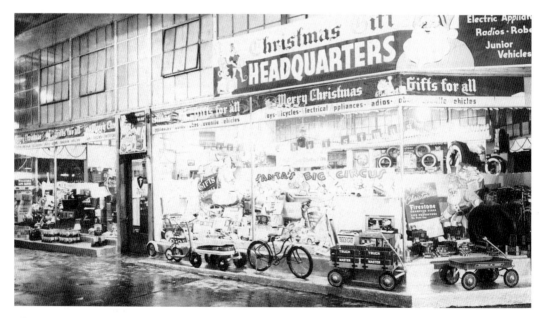

This Crosstown neighborhood Firestone Service Center was always a favorite place to shop for Christmas. They sold wagons, bicycles, scooters, and other wheeled toys for kids, as well as radios and appliances for adults. In this photograph, the bright glow of the building draws in customers on a wet fall night.

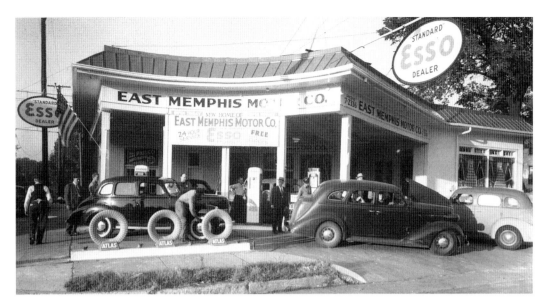

At the Esso filling station on Central Avenue, attendants checked the oil levels and tire pressures and washed windshields while filling cars with fuel. The success of these corner gasoline stations came from repeat business and the full service provided to their customers. Note the advertisement for 24-hour service.

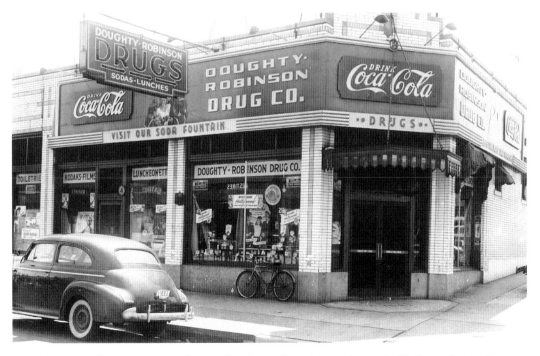

The corner drug store was much more than just a place where a pharmacist filled prescriptions. Its most popular feature was the soda fountain that served ice cream, soft drinks, and sandwiches. Here, the Doughty-Robinson Drug Company, located on Union Avenue, advertised Ex-Lax (note the thermometer), Forest Hill Milk, McKesson's cosmetics, and Kool cigarettes. The bicycle probably belongs to a delivery boy or neighborhood child.

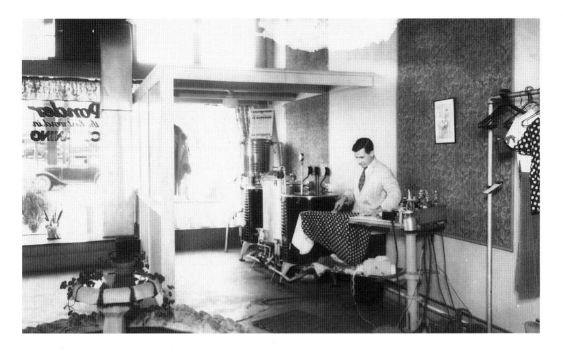

Several aspects of the Ponder Cleaners are unique. The indoor fountain seems quite modern as does the man ironing the skirt of the two-piece, polka-dot outfit. Local cleaners also provided alteration and pressing services.

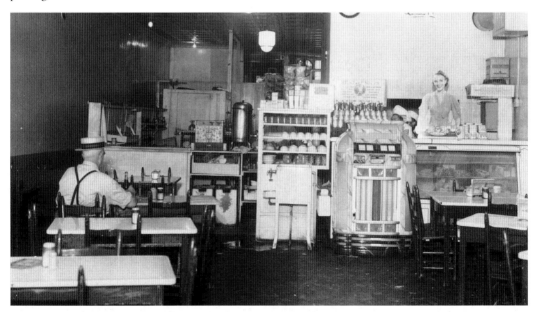

Joe Foppiano's Grill was one of Memphis' most popular bar and grills before World War II. Founded in 1915, Foppiano's catered to rich and poor alike, serving fine imported cheese sandwiches for 5¢ and steins of beer for 10¢. Other stores were charging 10¢ for sandwiches and 35¢ for bottled beer. During Prohibition, Joe was forced to sell Nip brand "near beer," of which he sold 30 barrels a day. His root beer on tap was also well known throughout the city.

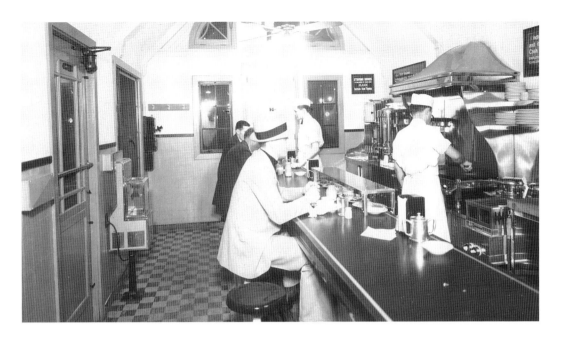

Toddle House restaurants are a Memphis icon, with their distinctive, steeply pitched roofs and their fast and friendly service. When they first opened in 1931, Toddle Houses had the unique feature of honor system payment. All prices were rounded off, so on their way out, customers just dropped the exact change in the box to the right of the door.

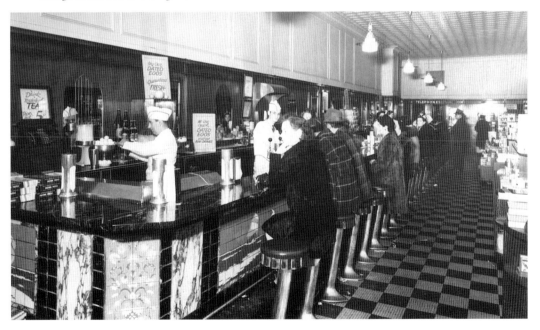

The soda fountain stools are full at the Pantaze Drug Store. With downtown locations on Beale Street and Main Street, Pantaze was one of the best-known drug stores in town. Details of the photo show women dressed in fur and at least one sailor at the counter, while an employee makes an egg drink from "fresh dated eggs." Note the marble-and-tile counter.

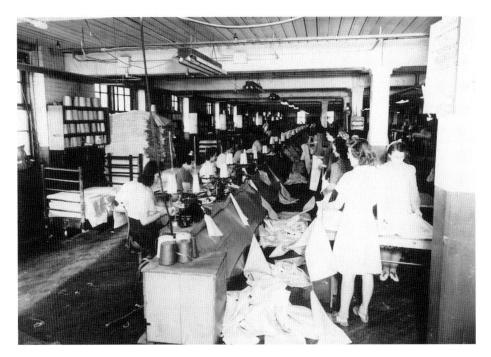

The Bemis Brothers Bag Plant in Memphis was only one of several bag plants the company operated across the nation. Pictured here, one group of workers in the Memphis plant sews the bottoms of cotton sacks shut while another group folds them. The brand names on the sacks are indistinguishable. Note the oil cans beside each sewing machine.

Tied to Memphis' role as a world leader in the cotton and timber industries was another agriculturally related business, the world's largest mule market. Until mules were replaced by tractors, the commission auctions at Memphis sold 45,000–60,000 per year. This string of 22 mules is being auctioned off in 1940 at the Smith-Podesta Mule Company, one of the city's largest mule companies.

nine

Beale Street:
Home of the Blues

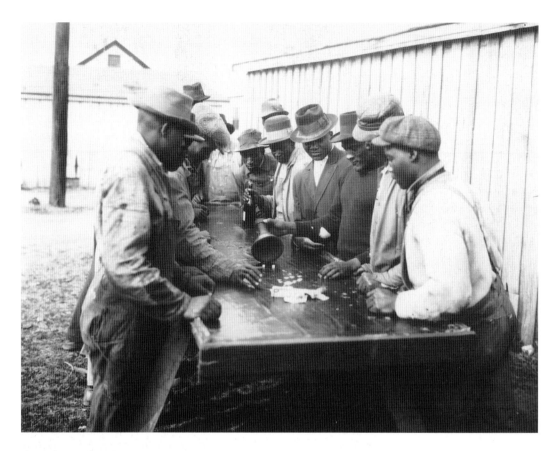

Above: Beale Street has a unique and colorful history. Originally named Beal Avenue, it was graced by many of the city's finest 19th-century mansions. One of Beal Avenue's pre-Civil War mansions, the William Richardson Hunt home, was briefly used as Grant's headquarters during the Federal occupation of Memphis. Gradually, the avenue became known as Beale Street. By the time W.C. Handy wrote "Beale Street Blues," the street had two completely different faces. With theaters, a church, nightclubs, an auditorium, and a park, the street served as the entertainment, religious, political, and economic center of Memphis' African-American community. The saloons, clubs, pool rooms, pawn shops, and run down tenements, however, revealed another side of the "Home of the Blues." Here, a group of men are shooting dice with a Hadden's horn on a table worn smooth from similar activities.

Opposite: The two photographs on this page portray the rural roots of what Beale Street is best known for—the Blues. This music, born in the Delta areas around Memphis, found a paying audience on Beale Street, where rural migrants continued to experience many of the same hardships they had encountered on the farm. They used this soul-stirring music to dance away their blues. A worker (pictured above) holds a tent rope out of the way to create a dance floor. In the image below, several men dance to a tune strummed by the guitarist on the front porch of a dogtrot house.

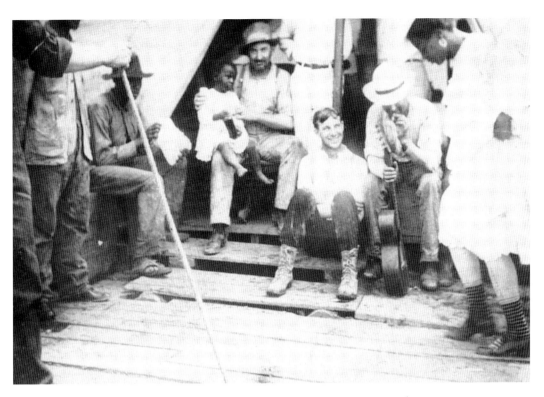

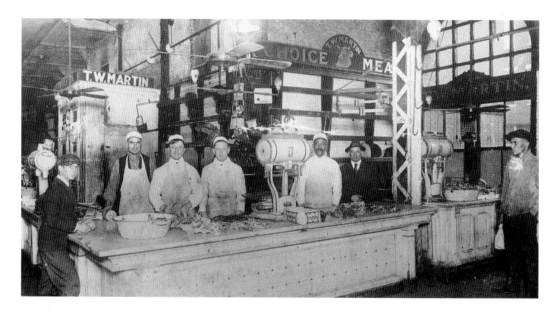

If the Beale Street Market didn't have it, you didn't need it. The market had dozens of stalls that sold fresh produce, meat, and other foods. At the T. W. Martin meat stall, all the fixings for another Memphis pastime––barbecue—could be purchased. Seen here taking time out from cutting ribs and chops, the butchers are (left to right) R. Sam Gray, Pete Garzoli, George Glatt, Sam January, and Vic Bosellini.

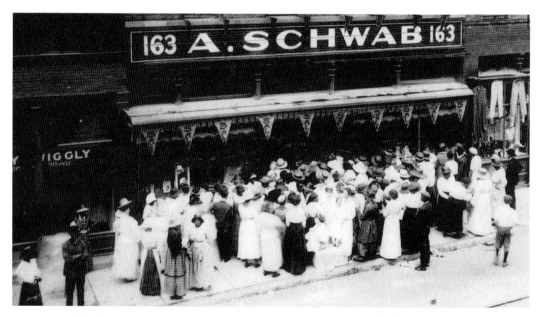

Founded in 1876 by Abraham Schwab, A. Schwab was, by far, the most successful dry goods store on Beale Street. The store was also known for its wide variety of unusual items. Customers could buy everything from voodoo potions to 7-foot-tall red underwear (seen here hanging to the right of the store entrance). Sale days brought out throngs of Memphians who shopped at Schwab's because of the economically priced goods. Today, this family-owned business still offers a back-in-time experience at the same Beale Street location.

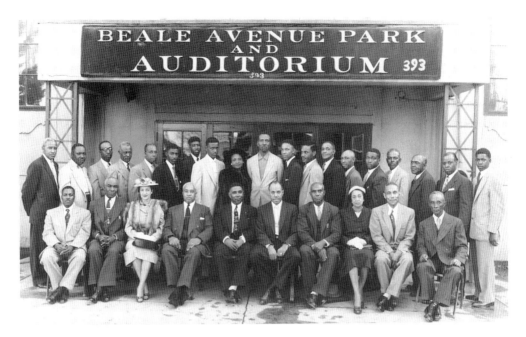

Church Park Auditorium was built as part of Church's Park in 1899. The 6-acre park also included a playground, grandstand, and gardens planted by Mrs. Robert Church, wife of the city's first black millionaire. The name was changed to Beale Avenue Park and Auditorium in 1940. Among the black leaders in the photograph above, Ethyl Venson, one of the founders of the Cotton Makers Jubilee (the African-American equivalent of the Cotton Carnival) is pictured third from the left in the front row.

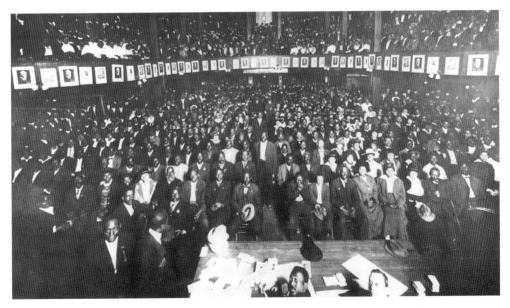

This photograph illustrates the role Church's Auditorium played in the development of Memphis' African-American community. It served as a cultural center and, as shown in the photograph, a political center. The group in this picture was gathered for the formative meeting of the Lincoln League, a black organization created in 1916 to support the Republican Party and the NAACP.

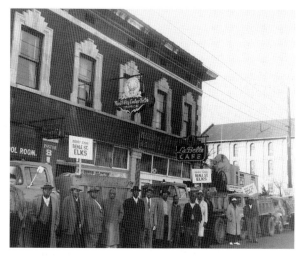

As one of the leading community organizations on Beale Street, the Elks of Bluff City Lodge No. 96 took an active role in many civic activities. In this view, City of Memphis dump trucks are being used to deliver Christmas baskets. Other establishments in this picture show the diversity of businesses on Beale Street. Located in the same building as the Elks Lodge is a pool room, a barber college, and a café. Church Park Community Center and the Beale Street Baptist Church can be seen on the right

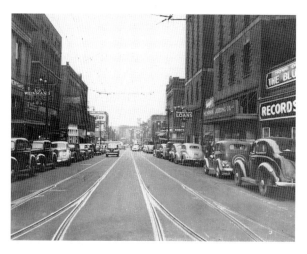

This block of Beale Street, east of Main Street, shows the diversity of businesses on Beale during World War II. Notice the high proportion of pawnbrokers and small hotels mixed with restaurants and the office of a day labor company. By the 1940s, blues music had gathered a large following that supported a thriving record business.

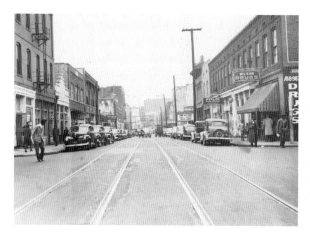

Memphis' African-American community adopted Beale Street as its own. Their "Main Street" offered everything they needed. Drugstores, tailors, doctors, dentists, photographers, and even a taxi service were packed shoulder to shoulder along Beale. The street's theaters, movie houses, bowling alley, and pool rooms all catered to African-American customers.

Left: The Palace Theater, the New Daisy Theater, and the One Minute Dairy Lunch were the premier hangouts on Beale Street. The Palace Theater is best known for its amateur contests hosted by Nat D. Williams and Rufus Thomas. Winners included such "unknowns" as B.B. King, Bobby "Blue" Bland, and Isaac Hayes. The New Daisy, built in 1941, was the most modern movie theater on Beale. In the 1930s, the One Minute sold 3,600 hot dogs per day.

Below, left: Construction of the Beale Street Baptist Church began in 1867. It is one of the oldest surviving church buildings in the South built and used by black citizens. The rose window is the building's most unique feature. Originally, the west tower was covered by a high steeple, and the east tower supported a bronze statue of John the Baptist. The church basement was briefly home to Ida B. Wells' Memphis newspaper.

Below, right: The entire neighborhood around Beale Street was dotted with rooming houses. Many of the rooms above Beale Street businesses were also rented, making the area a residential neighborhood as well as the community's business and entertainment center. Rooms for rent in the Beale Street neighborhood were conveniently accessible to downtown.

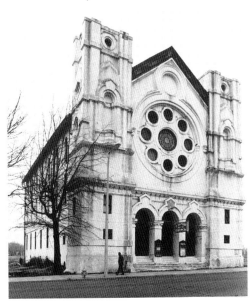

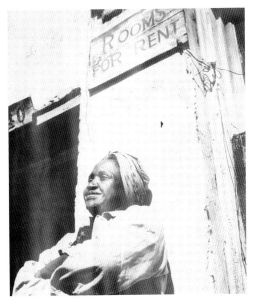

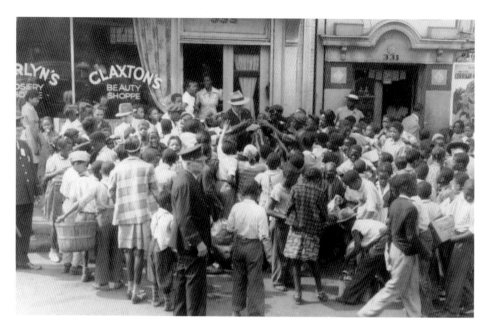

During World War II, scrap drives were an extremely important part of the war effort. In this view, young children are bringing in tin cans by the bushel to trade for free movie tickets being handed out by the theater owners. The movie showing at the New Daisy Theater was one of the Range Buster "B-Westerns" starring Roy "Crash" Corrigan, John "Dusty" King, and Max Terhune.

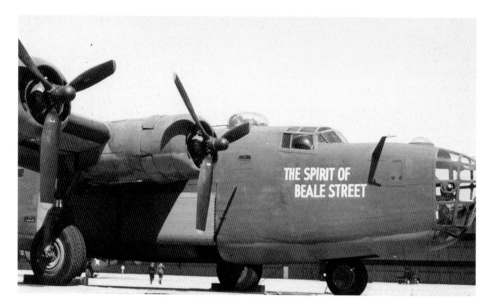

Although most Memphians know the story of the *Memphis Belle*, few know about The *Spirit of Beale Street*. This plane was paid for with the $303,000 in war bonds purchased by African-American Memphians during World War II. Republican political leader Lt. George W. Lee spearheaded the fund-raising drive. After the war, Memphis' own Tuskegee ace, Capt. Luke Weathers, received a hero's welcome with a parade on Beale Street. The event was attended by 20,000 Memphians.

ten

Blue Ribbons
and Midways:
The Mid-South Fair

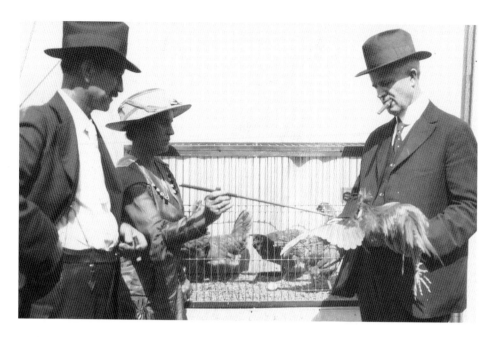

As the economic center of a large agricultural area, over the years Memphis has promoted the region's products with annual fairs. Memphis' first fair was held in 1856 and, with the exception of a few years after the Civil War and during the 1878 yellow fever epidemic, fairs have been held every year. The Tri-State Fair, founded in 1907, became the Mid-South Fair in 1929. The Fair offered a mix of rural agriculture, urban marketing, and midway entertainment to create an attraction that drew hundreds of thousands of Mid-Southerners to the Fairgrounds. The owner of the 1917 blue-ribbon laying hens is pictured here showing off her rooster to two men who appear to be big time chicken farmers (note the cigars). An egg is visible inside the coop.

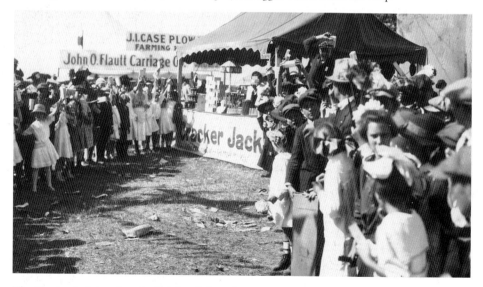

The Cracker Jack booth at the Fair handed out boxes of the popcorn treat to all the girls and boys promising "the more you eat, the more you want." There may have been some truth to their advertising; the Case and Flautt displays appear to be abandoned.

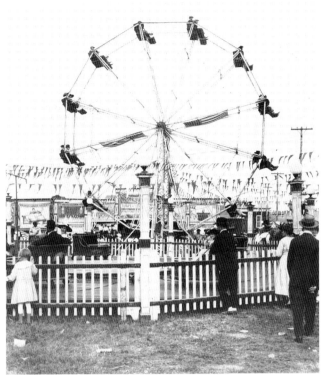

Left: What would a fair be without a Ferris wheel? This flag-decorated Ferris wheel is full of couples hoping to get stuck at the top. A crack-the-whip ride can be seen in the foreground, and signs advertising various sideshow attractions are in the background. Prior to television, fairs were considered the country's most popular form of public entertainment.

Below: Can you hear the barker cry, "Over the Falls!," "See the Boys Go!," "Lookout for the Whirlpool Rapids!" This 10¢ water ride from the 1910s appears to be pulling them in. It is unclear whether they are buying tickets to participate or just to watch. It was difficult to capture unstaged photographs such as this without people looking at the camera because the size of the equipment drew attention. The novelty of the camera also elicited reactions different from those of today.

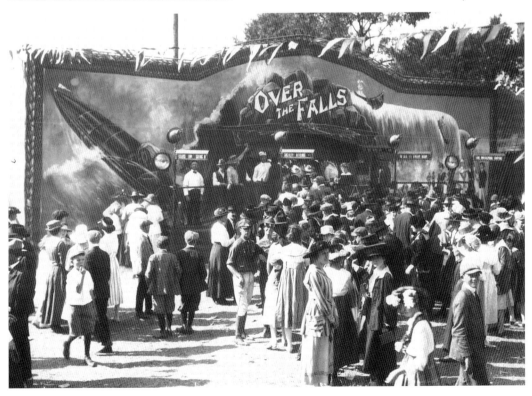

With so many dolls in stock, the game must be rigged. Although no signs tell the viewer what was required to win the doll, husbands and boyfriends would have had difficulty resisting the desire to win these cute little dolls for wives and sweethearts.

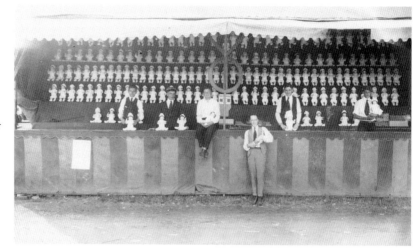

During World War I, the Fair was also used as a recruiting station for the military. In keeping with Tennessee's volunteer legacy, about 9,000 Memphians served during the war; 275 of those lost their lives. The doughboy statue in Overton Park was erected as a memorial to these local heroes.

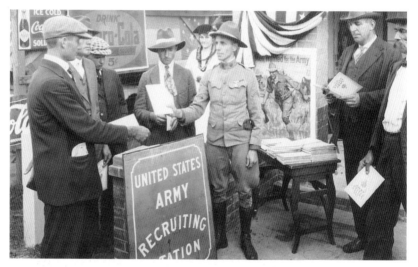

Patriotism was at an all time high during World War I. The posters encouraged potential recruits to "Follow the Flag," and be among the "First to Fight in France." These young men from a landlocked state may have been interested in the Navy or the Marines for the perceived adventure.

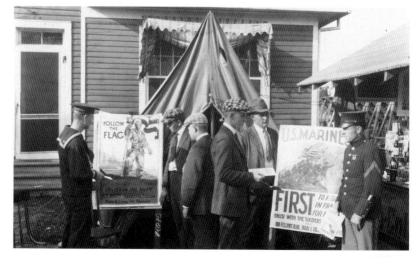

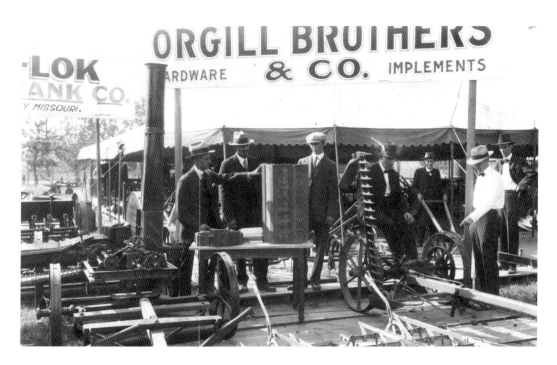

Farmers looking for a new plow, disk, harrow, sickle mower, or one of hundreds of other farm implements could look over the industry's newest equipment at the Fair. Orgill Brothers was one of the largest distributors of farm tools and implements in the South.

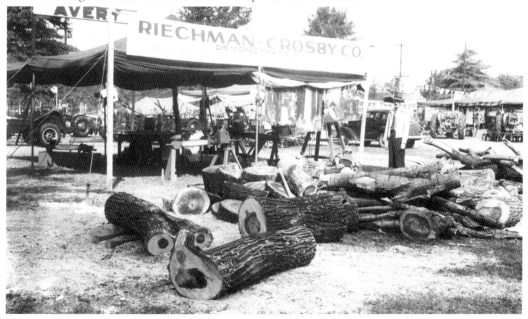

Although the new chainsaws shown in this display still required two men to operate them, they could now do the job much more quickly than with axes and crosscut saws. With these new saws, one man held the motor end while another held the handle on the end of the bar. In the background row after row of tractors can be seen.

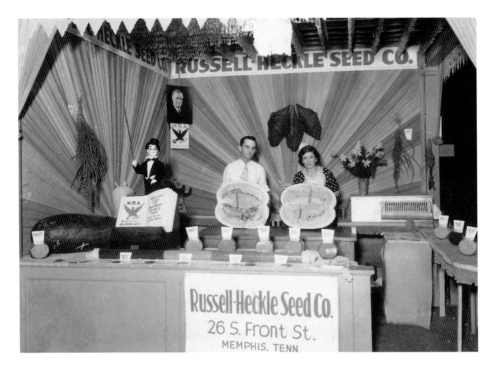

Indoor exhibits advertised everything imaginable. Here the Russell-Heckle Seed Company booth advertises seeds with names like "Beardless Barley," "Winter Hairy Vetch," and "Tennessee Crimson Clover." If Russell-Heckle seeds could grow a watermelon that big, what self-respecting farmer could do without them? The National Recovery Act material and the photo of FDR, coupled with the image of Charlie McCarthy, indicate that this 1934 image was taken during the time America was struggling to recover from the Depression.

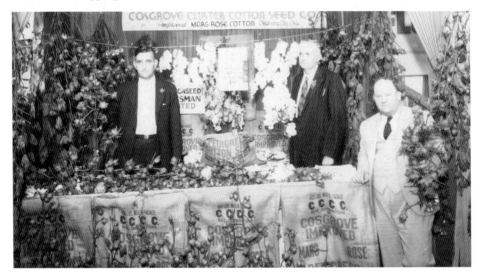

The growers of Cosgrove Improved Mars-Rose Cotton Seed won first prize for this booth at the 1934 Fair. True to their business, the men are wearing cotton bolls on their lapels. The seed sold for $1 per pound and $10 per bushel. The stalk on the right is more than 6 feet tall.

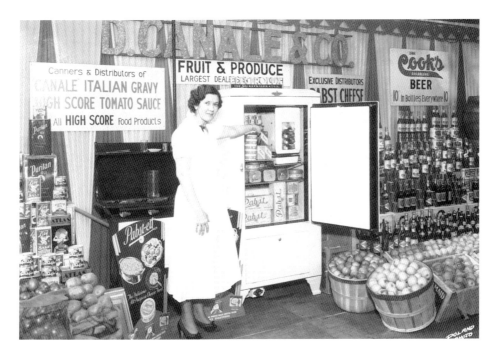

D. Canale & Company sold a little bit of everything, from potatoes to Electrolux refrigerators. They were particularly known for their beer distributorship—note Cook's 10¢ bottled beer. Canale also sold its own "High Score" line of canned products, which included malt syrup and Italian tomato sauce. The austerity of the Depression makes this 1934 food display seem extravagant.

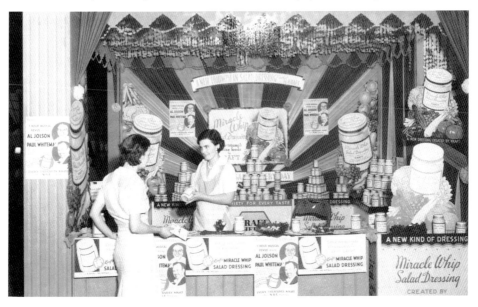

"Miracle Whip: Critical Hostesses Prefer it to Mayonnaise." Kraft Foods is using the Fair to introduce its new salad dressing to Mid-South residents. They may have already heard about the product while listening to Al Jolson and Paul Whiteman's Kraft Music Hall on NBC Radio. Before Miracle Whip, was a sandwich still a sandwich?

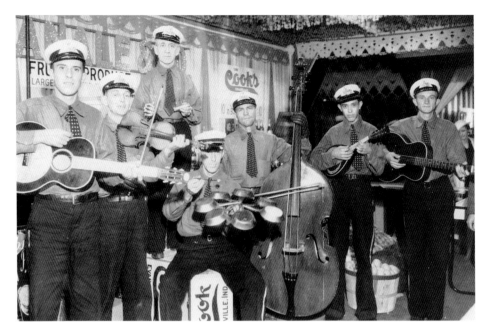

Fairgoers were often entertained by musical groups that were hired to help promote vendors' products. In this view, D. Canale & Company employs a variety ensemble complete with mandolin, "skillets," and an upright bass with only three strings. The harmonica player must have left his polka-dot tie at home.

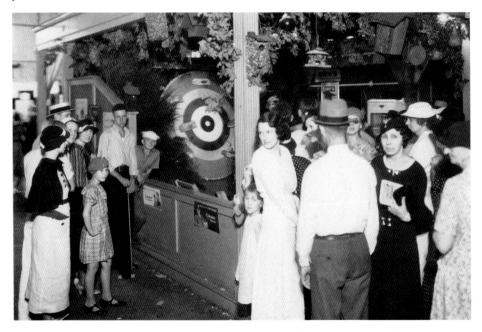

During the Depression, the Fair provided affordable entertainment to thousands of Mid-South residents. Competition is keen at the Colonial Baking Company booth. The birdhouses displayed as possible prizes were made by the Girl Scouts and Boy Scouts. A bull's eye could win a customer a birdhouse or a loaf of bread.

eleven

Memphians at Play:
Sports and Entertainment

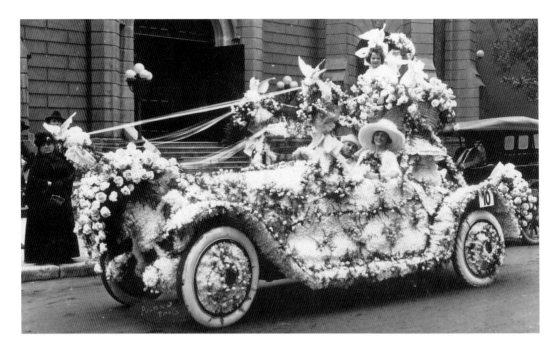

A wide-open river town in the 19th and early-20th centuries, Memphis was known as a place to have a good time. Frequently, this good time was associated with various vices. But, like today, people also participated in a wide range of popular entertainment activities such as sports, fairs, festivals, music, and theater. In May 1919, Memphis celebrated the centennial of its founding. Memphis women took an active role by organizing parades, decorating floats, and planning events. This elaborately decorated automobile is entirely covered with flowers. Note the little girl perched atop the car in a huge flower basket. The automobile was photographed in front of St. Peter's Catholic Church.

In the late 19th and early 20th centuries, harness racing was an immensely popular sport in Memphis. There were several courses around the city, including the North Memphis Driving Track (pictured here) and Montgomery Field at the fairgrounds. In harness racing, the driver and sulky are pulled by either trotters or pacers.

This shot of the timekeeper's booth shows the elite nature of the sport of horse racing. Note the variety of hats worn by the stylishly dressed men. The large mechanical clock gave official times to those in the grandstands who were betting on the races.

The East End Park was Memphis' first amusement park. Located at the eastern edge of the city, streetcar transportation was provided by the East End Dummy Line. This c. 1911 photograph shows the large carousel. Other popular features included a pavilion for dances and shows, a lake complete with boats, a beer garden, and two roller coasters: the "Dips" and the "Figure Eight."

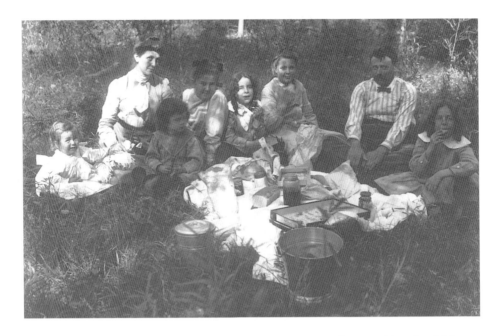

Raleigh Springs, out in the county, was another popular destination for Memphians. In addition to staying in the lodge and using the medicinal waters of three springs, families also enjoyed picnics on the grounds. The Frank family is enjoying a meal that includes bread, apple jelly, jam, and fried chicken—a Southern picnic staple.

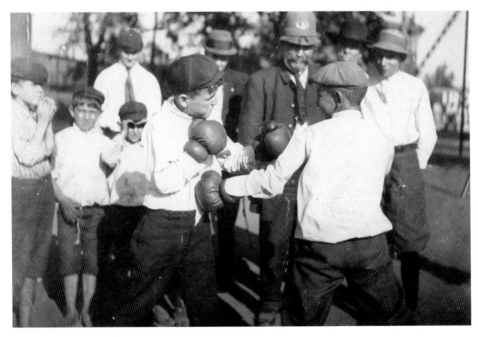

This playground fight seems to be under better control than most. A police officer is supervising while two gloved boys learn how to throw jabs, hooks, and uppercuts. This is possibly an attempt to control juvenile delinquency by teaching the finer points of boxing.

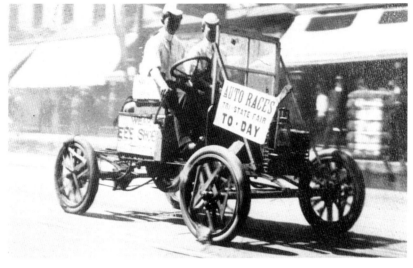

This unusual parade entry advertises the fact that an auto race was being held at the Tri-State Fair racetrack. Other aspects of the photo, however, are puzzling. Why is there a sign on the car encouraging people to wear triple E shoes (the answer is on p. 70), and why is the steering wheel on the right side of the vehicle?

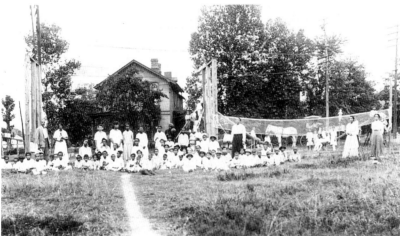

In this view, a group of students and their teachers pause from the day's activities to have their picture taken. The school's playground boasts four swings, a slide, and a volleyball net. Two other items of interest are the apparent lack of older boys and the well-worn path, presumably leading to the school.

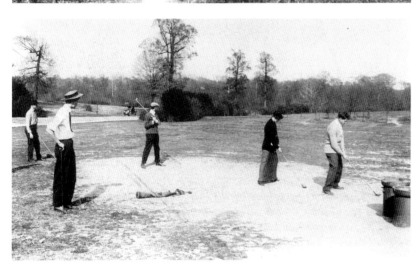

Driver or putter? As small as their golf bags were, club selection was probably not a problem. In this view, four men and a young lady tee off from one of Memphis' early golf courses. An interesting footnote: because of the hardwood timber industry here, several golf shaft and head manufacturing companies were located in Memphis.

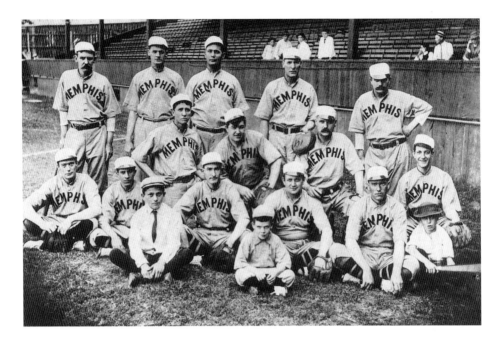

This photo of an early baseball team shows how the game has changed over the years. The catcher doesn't have a mask (but his glove is 2 inches thick) and the ball is almost black in color. Some things, however, like fans showing up for photo opportunities, stay the same.

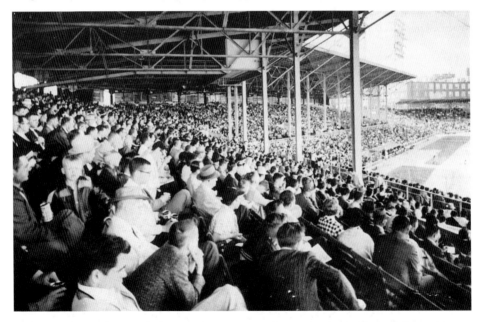

Memphians have always loved baseball. With teams like the Chicks, the Turtles, and the Red Sox (the Memphis Negro League team), fans flooded to the ballparks. In this photo, the crowd is watching a game at Russwood Park. A fire destroyed Russwood on Easter evening, April 17, 1960, in Memphis' first five-alarm fire. Heat from the fire cracked windows in the Baptist Memorial Hospital, located on the opposite side of Madison Avenue.

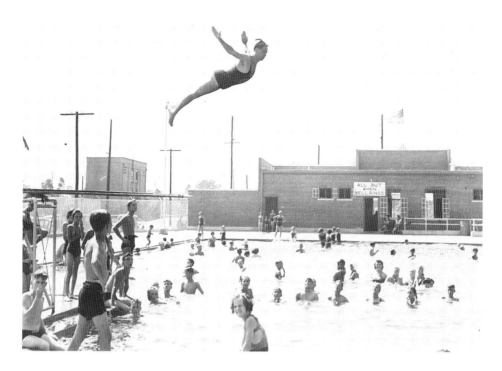

Look out below! Is this a swan dive or a belly flop? Who cares as long as you're having fun and escaping Memphis' summer heat and humidity. In this view, a pool full of kids enjoy the water at the Malone Municipal Pool. The diver typically draws everyone else's attention, but a few are more interested in the camera.

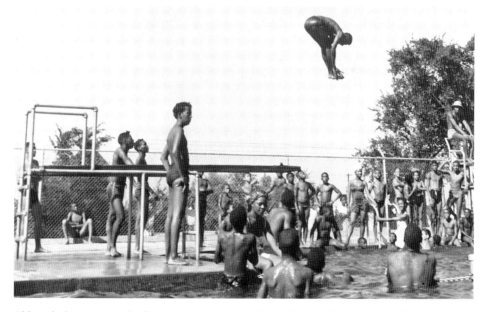

Although there seem to be fewer swimmers in the Orange Mound Swimming Pool, the diver has much better form. Almost everyone is watching his performance. At that time, swimming pools, like most other public institutions, were segregated.

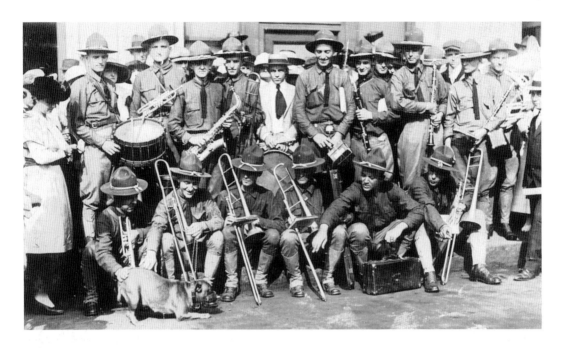

A military band is taking a break after playing in a parade. The dog in the foreground doesn't seem too happy with the attention he's getting. Though the trumpet player and the trombone player are pushing their luck, the man holding the dog's chain doesn't seem too concerned.

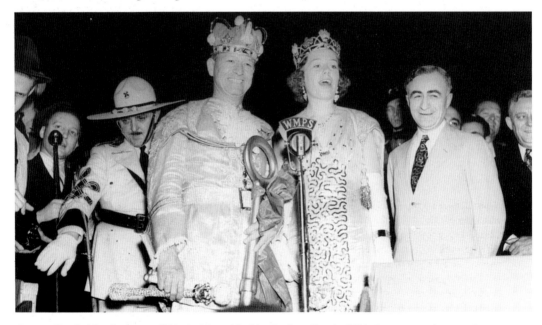

Cotton Carnival has been a tradition in Memphis since its founding in 1931. Its roots can be traced to the early Memphis Mardi Gras festivals of the 1870s and 1880s, which rivaled those in New Orleans. Cotton Carnival King Jack Hayes and Queen Elizabeth Campbell, along with Memphis Mayor Watkins Overton, are pictured greeting the thousands of Memphians who have come to the river's edge to welcome the royal barge.

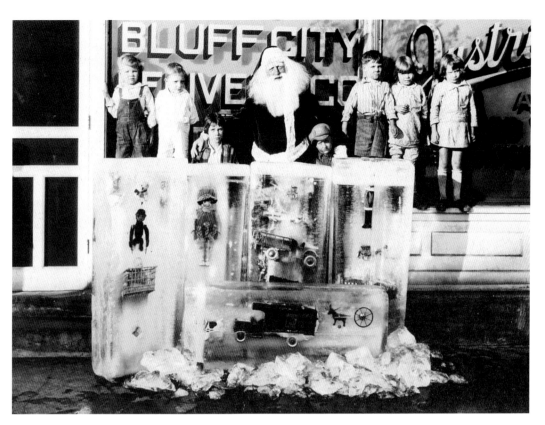

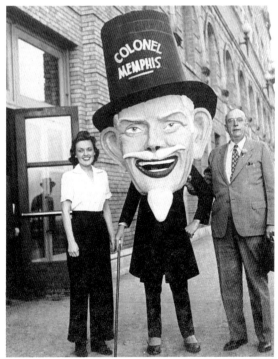

Above: The Goodfellows was a Memphis service organization that distributed toys and clothing to needy children at Christmas. The pants of one boy (third from the right) appear too big for him. Frozen in ice are all kinds of toys: puppy dogs, monkeys, donkey carts, dolls, toy soldiers, fire trucks, and even a baby doll in a bicycle basket—some defrosting was required.

Right: Between 1948 and 1961, Memphis was awarded the title of the Nation's Cleanest City four times. The Memphis City Beautiful Commission was largely responsible for these designations. Founded in 1930, the commission was the first city beautification commission in the nation. Colonel Memphis is pictured in this view, ready to lead the Commission's Clean Up, Paint Up, Fix Up parade.

The Memphis Zoo was established in 1905 when a bear named Natch, the former mascot of the Memphis Turtles baseball team, was chained to a tree in Overton Park. Public outcry soon initiated the creation of a municipal zoo. As the animal population grew, additional buildings were added, including the carnivore and elephant houses and the open-air aviary shown here. Built in 1937, the large upper cage was home to a condor and several eagles and vultures. A separate enclosure for pheasants and Japanese Silky Chickens encircled the aviary.

In addition to its zoo, golf course, and the Brooks Art Museum, Overton Park was also the home of a spectacular Japanese garden. After the attack on Pearl Harbor, the Memphis Park Commission proclaimed its intent to "avenge Pearl Harbor," and on January 2, 1942, the entire garden was razed to the ground. This hostile reaction of the park commission shocked many Memphians. Today, a large Japanese garden is a major feature of the Memphis Botanic Garden.

Acknowledgments

The quality of the photograph collections held by the Memphis/Shelby County Room is the real reason I proposed that this book be written. Thanks should be given to the hundreds of individuals who over the years have donated photographs to the History Department as well as all those who helped create the contact print index which makes finding appropriate images much easier.

The administration of the Memphis/Shelby County Public Library and Information Center has been very supportive of both my work on this project and my wish that all the proceeds for the book be given back to the Memphis/Shelby County Room. I want to particularly thank Dr. Jim Johnson, History Department Head, for his overall direction and guidance. Special thanks is extended to the Foundation for the Library for their support of this project.

My co-workers in the History Department have been my major support for this book. Some have assisted me with ideas, others have helped research details for the captions, and most have read the drafts several times. The editorial experience and local history knowledge of three of my co-workers, Patricia LaPointe, Stephanie DeClue, and Wayne Dowdy, have made this book much more readable than it would have been otherwise. A very well-deserved thank you also goes out to Betty Blaylock, Joan Cannon, Jill Davis, Dr. Barbara Flanary, Thomas Jones, Bucke Pickett, Donald Strickland, Belmar Toney, and Marilyn Umfress.

My wife, Patricia, and son Hunter have been the real heroes in the publication of this book. They have put up with my late hours and reinvigorated my spirit.

Bibliography

Biles, Roger. Memphis in the Great Depression. Knoxville: University of Tennessee Press, 1986.

Capers, Gerald M. Jr. *The Biography of A River Town*, 2nd edition. Memphis: Burke's Book Store, 1980.

Coppock, Helen and Charles W. Crawford, eds. *Paul R. Coppock's Mid-South*, vols. 1–4. Nashville: Williams Printing, 1985–1994.

Coppock, Paul. *Memphis Memoirs.* Memphis: Memphis State University Press, 1980.

————. *Memphis Sketches.* Memphis: Friends of the Library, 1976.

Crawford, Charles Wann. *Yesterday's Memphis.* Miami: E.A. Seeman, 1976.

Harkins, John E. and Berkley Kalin. *Metropolis of the American Nile: An Illustrated History of Memphis and Shelby County.* Woodland Hills, CA: Windsor Publications, 1982.

Johnson, Eugene J. and Robert D. Russell Jr. *Memphis: An Architectural Guide.* Knoxville: University of Tennessee Press, 1990.

Lanier, Robert A. Memphis in the Twenties. Memphis: Zendra Press, 1979.

LaPointe, Patricia M. *From Saddlebags to Science: A Century of Healthcare in Memphis, 1830–1930.* Memphis: Health Sciences Museum Foundation, 1984.

Magness, Perre. Past Times: Stories of Early Memphis. Memphis: Parkway Press, 1994.

Memphis/Shelby County Information File. Memphis/Shelby County Room, History Department, Memphis Shelby County Public Library and Information Center.

Miller, William D. Memphis During the Progressive Era, 1900–1917. Memphis: Memphis State University Press, 1957.

————. Mr. Crump of Memphis. Baton Rogue: Louisiana State University Press, 1964.

Raichelson, Richard M. *Beale Street Talks: A Walking Tour Down the Home of the Blues.* Memphis: Arcadia Records, 1994.

Sigafoos, Robert A. *Cotton Row to Beale Street: An Economic History of Memphis.* Memphis: Memphis State University Press, 1979.

Yellin, Emily. *A History of the Mid-South Fair.* Memphis: Guild Bindery Press, 1995.

Wrenn, Lynette B. Memphis: Elite Rule in a Crisis and Commission Government in a Guilded Age City. Knoxville: University of Tennessee Press, 1998.